Table of Contents

Letter from the Editor

Welcome to the Palliative Turn ...Westphalen ⑨

Soil and Green Jana Thiel ⑪

Health Data Keith Larson ⑬

Thoughts on *Flaschen* Marit Neeb ⑯

REPORT: AFASIOTOPIA — The First Art Symposium at Salon am Moritzplatz, Berlin ⑱

Exercise: Palliative Pilates Simon Blanck ⑲

REPORT: Lydia Roeder's Workshop on Palliative Care ⑳

Palliative Assessment Form Kasia Fudakowski ㉒

Know That Hello Also Means Goodbye — On Trying to Be a Palliative Artist Dafna Maimon ㉓

REPORT: *The Palliative Turn* at Brandenburgischer Kunstverein Potsdam ㉘

The Association's Way of Working Means Less Progress Than Process Marit Neeb and Nadja Quante ㉚

REPORT: The Unspoken Consort, Concert at Brandenburgischer Kunstverein ㉞

REPORT: *An Evening on the Palliative Turn* at Pogo Bar, KW Berlin ㉟

REPORT: An Audience Perspective on *An Evening on the Palliative Turn* Niki Katsara ㊱

A Call for the Palliative Turn — Manifesto (Centrefold) ㊳⁄㊴

Exercise: Be Present and Free From Stress
Annemarie Goldschmidt ㊵

Last Night I Dreamt I Was a Shoe Teal Griffin (42)

Soil and Green Jana Thiel (44)

At Least We Tried Karin Kytökangas (46)

Preparing for the Palliative Turn
Lars-Erik Hjertström Lappalainen (47)

Life Precedes Death — Death Ends Life
Annemarie Goldschmidt (49)

REPORT: The First Palliative Audit by AP_T (50)

**REPORT: *The Palliative Turn*
at Künstlerhaus Bremen** Teal Griffin (52)

Email Call For Male Models Laura Pientka (55)

**REPORT: An Outside Perspective
on the Audit in Bremen** Rose Sanyang-Hill (57)

REPORT: Drawing Sessions
Monika M. Beyer (58)

Wie stirbt man genau? Ruth Rubers (59)

Mom Tattoo Olav Westphalen (61)

Crowd Mum Louise Ashcroft (62)

**REPORT: Cabaret Impedimenta
at the Edinburgh Festival Fringe** Harry Haddon (64)

AP_T Reads (66)

**Ways to Foster a Healthy Relationship with
Death: A Non-Hierarchical List** John-Luke Roberts (70)

Black Circle Astrology Maxwell Stephens (71)

AP_T Timeline (73)

Contributors, Imprint (74)

Dear Readers,

You are holding in your hands the first issue of *The Palliative Turn*, a magazine dedicated to the activities of the Association for the Palliative Turn (A^P_C), which has, sort of, been around since 2020 or 2019, depending on how you define 'association' and 'being around'. This publication is released on the occation of an exhibition at the Künstlerhaus Bremen which brought together some 30 artists and non-artists who are all in their own different ways connected to the association.

The notion of a palliative cultural turn is a speculative proposal. It is by no means a precise or complete theoretical edifice. The intuitive desire to turn our backs on the widely accepted curative paradigm, which stems from European enlightenment and Christianity alike, doesn't come out of indifference towards suffering, nor is it an excuse for giving up. On the contrary, it stems from the realisation that our long-held belief that we can 'cure and fix' our way out of any predicament, and the specific ways we have gone about it, has led us down the wrong path, creating new forms of suffering.

The Palliative Turn proposes a fundamental shift in our attitude towards art and culture, informed by the practices of palliative medicine and care. If this proves fruitful, it may bleed further into what is called reality. We're not the first ones to suggest that life changes for the better when death is acknowledged, rather than denied.

A practical note—for the practical is eminently palliative—the predominant language of our conversations within the A^P_C have been in English (albeit with a range of accents, inflections, and exclamations from other tongues). This is why the language of this publication is English too, despite it being published in Germany. In a few cases we decided to leave contributions that were written in their original language. We hope that this publication feels like a multi-layered, multi-vocal, open-ended, lively conversation, rather than the unified communications of a monolithic institution.

The A^P_C is an association only in the loosest sense. One of the early adopters, the artist Kasia Fudakowski, has described it as a 'gathering of the palliatively curious'. There is no formal structure, no membership status, no membership fees. Most contributors to this magazine, and to the accompanying exhibition, would probably not agree about what the Palliative Turn signifies. But they do agree that in itself, this is an interesting place to be, at the beginning of a dialogue, leaning into a turn that has yet to be charted, but that seems promising and even pleasurable (compared to the 'business as usual' straight ahead and all around us).

All this looseness makes working with the A^P_C a real challenge. We owe a sizeable measure of gratitude to the institutional partners who have had the courage to work with us, namely to the Künstlerhaus Bremen, its artistic director Nadja Quante and her amazing team and members, but equally to the Brandenburgischer Kunstverein Potsdam and its director Gerrit Gohlke who gave us our first institutional exposure, as well as Marit Neeb who was instrumental in producing that first exhibition and who is now a member of A^P_C.

We hope you will enjoy this premier issue of *The Palliative Turn*.

It

 may

be our last.

Liebe Leser:innen,

In Ihrer Hand halten Sie die erste Ausgabe von *The Palliative Turn*, einer Zeitschrift über die Aktivitäten der Association for the Palliative Turn (APT). Der „Palliative Turn" ist ein von uns neu eingeführter Begriff, der als „Palliative Wende" übersetzt werden kann. Die APT ist also die Vereinigung für die Palliative Wende. Sie existiert seit 2020 oder 2019, je nachdem, wie man „existieren" und „Vereinigung" definiert. Die APT ist nie offiziell gegründet worden, sondern schrittweise aus gemeinsamem Interesse gewachsen. Dieses Heft erscheint anlässlich einer Ausstellung im Künstlerhaus Bremen, an der über 30 Künstler:innen und Nicht-Künstler:innen, die auf unterschiedliche Weise mit der APT verbunden sind, teilnehmen.

Die Behauptung einer bevorstehenden palliativen Wende ist ein spekulativer Vorschlag. Es steckt keine ausformulierte Theorie dahinter. Die unbehagliche Ahnung, dass es an der Zeit ist, der zurzeit vorherrschenden kurativen und instrumentellen Denkweise in der Kunst, die gleichermaßen in der europäischen Aufklärung und der christlichen Moralität verwurzelt ist, den Rücken zuzukehren, hat nichts mit Gleichgültigkeit gegenüber Problemen und gegenüber realem Leid zu tun. Es ist auch keine Ausrede, um einfach aufzugeben. Im Gegenteil: Die palliative Wende fußt auf der Ablehnung des Glaubens daran, dass wir uns durch Wissen und Aufklärung noch aus jeder Problemlage herausfinden, -kämpfen und -medizinieren können und müssen. Sie fußt darüber hinaus auf der Einsicht, dass uns dieser längst zur Gewohnheit gewordene Glaube auf den falschen Weg geführt hat. Die Art und Weise, in der wir Probleme lösen, führt offensichtlich zu immer neuen, immer größeren Problemen.

Die palliative Wende orientiert sich an den Prinzipien und Erfahrungen der palliativen Medizin und Pflege und wendet diese auf Kunst und Kultur an. Das bedeutet den Beginn einer grundsätzlichen Perspektivverschiebung. Sollte sich diese als fruchtbar erweisen, könnte eine palliative Haltung auch andere Bereiche unserer Erfahrung durchdringen. Wir sind ja nicht allein in der Annahme, dass das Leben sich zum Besseren wendet, wenn der Tod akzeptiert und nicht verdrängt wird.

Ein praktischer Hinweis — denn das Praktische ist ausgesprochen palliativ — zur Sprache dieser Ausgabe: Der Austausch unter den APT-Mitgliedern findet vorwiegend auf Englisch statt, wenn auch in einer Reihe verschiedener Akzente und mit Einwürfen in diversen anderen Sprachen. Entsprechend wurden die meisten Magazinbeiträge auf Englisch verfasst und nicht übersetzt, obwohl wir in Deutschland publizieren. In einigen wenigen Fällen haben wir Beiträge, die deutsch verfasst wurden, im Original belassen. Wir hoffen, dass sich dieses Heft wie eine vielschichtige, vielstimmige, offene und lebendige Konversation liest, nicht wie die Verlautbarung einer einheitlichen Organisation.

Die APT ist nämlich die loseste Vereinigung, die man sich denken kann. Eines der frühesten Mitglieder, die Künstlerin Kasia Fudakowski, hat sie als „Zusammentreffen der palliativ Neugierigen" beschrieben. Es gibt weder feste Strukturen noch eine offizielle Mitgliedschaft oder Mitgliedsbeiträge. Die meisten Autor:innen dieses Magazins wären sich wahrscheinlich uneins darüber, was der Palliative Turn bedeutet. Aber sie sind sich sehr wohl einig darüber, dass dies ein interessanter Moment ist, am Beginn einer Wende, sich leicht in eine Kurve lehnend, die noch gar nicht gezeichnet ist, die aber vielversprechend klingt und

sogar Freude verspricht (verglichen mit dem schleppenden „business as usual" rundherum).

Unschärfen und Missverständnisse sind dabei zu erwarten. Sie machen aber die Zusammenarbeit mit der A&G zu einer echten Herausforderung. Wir sind daher den Institutionen, die den Mut haben, mit uns zu arbeiten, sehr dankbar. Vor allem sind das das Künstlerhaus Bremen. Dessen künstlerischer Leiterin Nadja Quante, ihrem Team und den engagierten Mitgliedern des Künstlerhauses sind wir zu Dank verpflichtet. Ebenso wichtig sind der Brandenburgische Kunstverein Potsdam, dessen Direktor Gerrit Gohlke uns zu unserer ersten institutionellen Ausstellung eingeladen hat, sowie Marit Neeb, die die Produktion dieser Ausstellung entscheidend unterstützt hat und nun selbst A&G-Mitglied ist.

Wir hoffen, Sie finden diese erste Ausgabe von *The Palliative Turn* interessant und relevant und haben sogar Freude daran.

Es
 könnte die
 letzte
 sein.

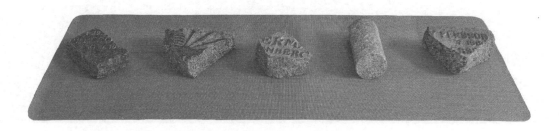

A selection of five different Palliative Pilates blocks.

When your mouth is all dried up like a potsherd you can count on Proxident mouth swabs.

Soothing till the end.

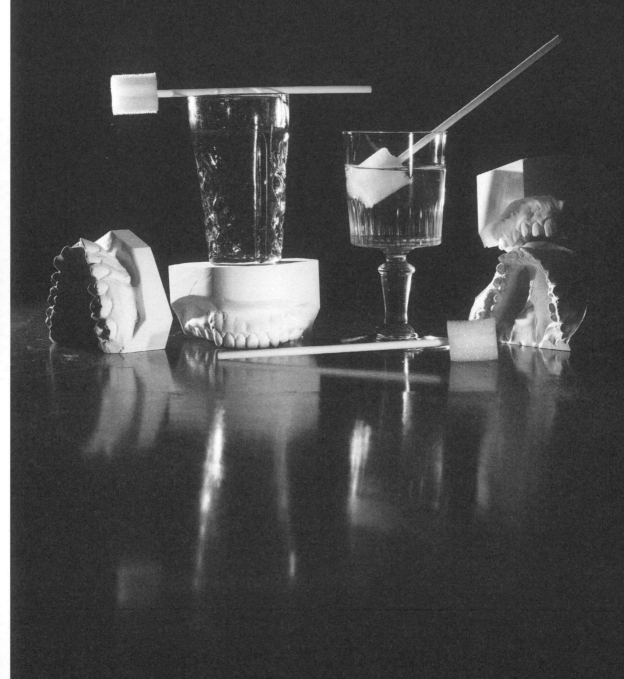

Welcome to the Palliative Turn

Olav Westphalen

You will die and so will I.
This much we know.
What's new is that there may be nobody around to pick up where we left off.

The steam engine was invented barely 300 years ago. If humans stopped burning coal, gas, oil today and no cow ever farted again, it would still take between 100,000 and 400,000 years for the earth's climate to cool down to pre-industrial levels. This calculation brings home the scope and time frame of our problems. More than half of the greenhouse gases in the atmosphere have been added since the year 2000.

For about a decade, I have been facilitating a dialogue between artists and climate scientists working at the Swedish Polar Research Station. With increasing urgency, the scientists have been asking the artists how they can communicate their knowledge of the imminent catastrophe we are facing in ways that have an impact. Might there be another narrative, different from the ones we have been using, something beyond skinny polar bears, collapsing ice shelves, and the frail, blue marble, something that could mobilise populations and politicians to finally act? Art, the scientists are hoping, may be able to create the necessary effect that factual information clearly doesn't achieve.

A recent cancer treatment forced me to consider death in concrete and personal terms. Along the way, I met health care professionals and fellow patients whose pragmatism and kindness under extreme conditions were incredible. Against this backdrop, much of contemporary art felt somewhat irrelevant. In a coincidental development, the cartoonist Marcus Weimer and I were commissioned by the German Association for Palliative Medicine to provide a 'humour concept' for the international convention they were organising for September 2020. They had been considering how humour could benefit palliative medicine and care; not just in the form of hospital clowns, but rather as an overall shift in attitude toward death, which is not only tragic but also grotesque, and therefore potentially funny. The convention, whose title translates as 'Controversies at Life's End,' focused primarily on the contrasting strategies of assisted suicide on the one hand, and palliative care for the dying on the other. It was a nuanced debate well above our cartoonists' heads. What struck me most was how much of palliative thinking is about the value of life, the pleasure of being alive even on the last lap. There were stories of ingenious hospital staff deep-freezing liquor to put tiny bits of ice into a patient's mouth, allowing her to taste her favorite whisky when she was no longer able to swallow, and the Mother Superior at a Catholic hospice who, against all her beliefs, hired a prostitute to spend time with a seventeen-year-old who didn't want to die without having had sex. Palliative care is not only about mitigating suffering; it is at least as much about affirming the value of life in general, and specifically of the individual life that is about to end. It honours the richness of sensory experience until the very end.

At some point, it occurred to me that the Swedish climate scientists may have been posing the wrong question to us artists. Cultural narratives, art works, films, and books that try to mobilise and usher in change are aplenty. Many of them are smart, sensitive, beautiful. But they are generally based on the assumption that somehow—through education, information, reason, technology, or political action—we can solve our problems. What if this assumption about our capacity for fixing things were just another facet of our hubris, of the self-aggrandising, western-style exceptionalism that got us into trouble in the first place? What if our ambition to control and manage not just our own lives but even the planetary climate's equilibrium is just the latest symptom of what has been wrong all along? And, finally, could acceptance of our predicament,

of the impending end of — at the very least — this type of civilisation, and learning how to die well be a first step toward learning how to live better? Living better, one would hope, might imply a less destructive presence. (This is, ironically, where hubris can sneak in again.)

Much of contemporary art up to now (and I include my own efforts here) has derived its legitimation from some claim, however vaguely implied, to making things better. It usually tries to do so by employing classic strategies of the enlightenment, such as critique, exposure of ideologies, awareness-raising, and so on. While art usually isn't put to direct use, it still is expected to lean towards solutions, however poetically or indirectly. Such art could thus be described as curative art, or at least as art with a curative tendency. Art that is on the right side, that does more good than bad. What if artists started from the opposite end, by first acknowledging that things, cultures, individuals will go under, and that art cannot change this? In this light, what kind of art or culture do we want to make and experience? Artists instinctively project themselves into the future and derive their significance from this self-ascribed historical agency. What if we took that future out of the equation?

Between the first and second wave of the COVID-19 pandemic, a group of the palliatively curious — individuals interested in reimagining the role of art and artists in relation to collapse, finality, and death rather than to an idealist framework of history and progress — gathered in Berlin for an informal symposium.[1] Over the course of four days, participants tried to sketch out in a series of talks, experiments, and performances a general concept of what art after the Palliative Turn might look like, and which aspects of palliative care could be transferred to art. It was the first step in an open-ended cooperation, dedicated to the advancement and communication of the Palliative Turn.

In a subsequent step, the participants became the founding members of A^P_G, the Association for the Palliative Turn, which is now exploring a range of possible activities, including the development of a rating and certification system for Palliativity in Art (how palliative is it?); Palliative Turn Counseling for artists, cultural institutions, dealers, collectors, and others; and the cultivation of Palliative Comedy. Palliative care has some useful models to offer. The 'total pain' concept, for example, looks at pain from all aspects of life: physical, psychological, social, and spiritual. Social and spiritual death often precede physical death but are easily overlooked.

Another interesting tool is a model that distinguishes between anticipatory grief, the grief of dying, and survivors' grief. Anticipatory grief occurs before death (or another great loss), and in contrast to conventional, or survivors' grief, it is experienced jointly by the dying, their families and friends, and even the care staff. In addition to sadness about the impending death, anticipatory grief has many other aspects, including anguish over the loss of companionship, changing roles in the family, financial upheaval, and the demise of unrealised dreams. A^P_G operates from the understanding that humanity has collectively entered this phase of anticipatory grief. As we face the end of civilisation as we know it, each of us is patient and caretaker and soon-to-be bereaved at the same time.

In the case of the frustrations expressed by the Swedish climate researchers, a first and admittedly modest contribution by A^P_G could be the application of the concepts

1 The participants in AFASIOTOPIA (A Foundational and Speculative Invocation of the Office of Palliative International Art) included artists Simon Blanck, Kasia Fudakowski, Nina Katchadourian, Dafna Maimon, Olav Westphalen; comedian John Luke Roberts; kinesiologist Annemarie Goldschmidt; and art critic and philosopher Lars-Erik Hjertström Lappalainen. External input, both before and during the symposium, came from climate scientist Keith Larson; palliative care expert Lydia Röder; Pia Kristoffersson, a former curator of contemporary art, now a mortician; funeral director Stephan Hadraschek; and various members of the German Association for Palliative Medicine. Since then, A^P_G has grown. There are now around 30 artists and other professionals who are somehow engaged in the association.

of anticipatory grief and total pain to debates around climate change. It might allow us a collective understanding of the layers of pain and the types of death we are all experiencing. In this way, we can begin to see even climate change deniers and profiteers not as greedy cynics or as scientifically ignorant dunces, but instead as patient-caretakers, or family members who are entering that confusing, frightening period before the end. A period that, as palliative care shows, can be a time of insight, growth, and deep enjoyment of everything that still is. A^P_C proposes that we not waste this time on nail biting, name calling, and holy hatred, but rather use it for a blossoming of culture and compassion, a time of authentic bliss and laughter flanked by sincere sadness—a time that would be remembered as golden and wise, should anyone still be around to remember it.

This essay was commissioned in April 2021 for the final printed issue of *Cabinet Magazine*, titled *The End*, which is still pending publication.

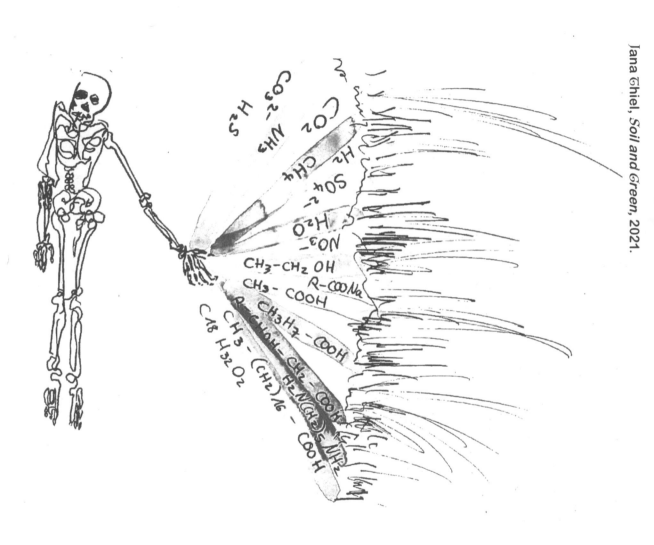

Jana Ghiel, *Soil and Green*, 2021.

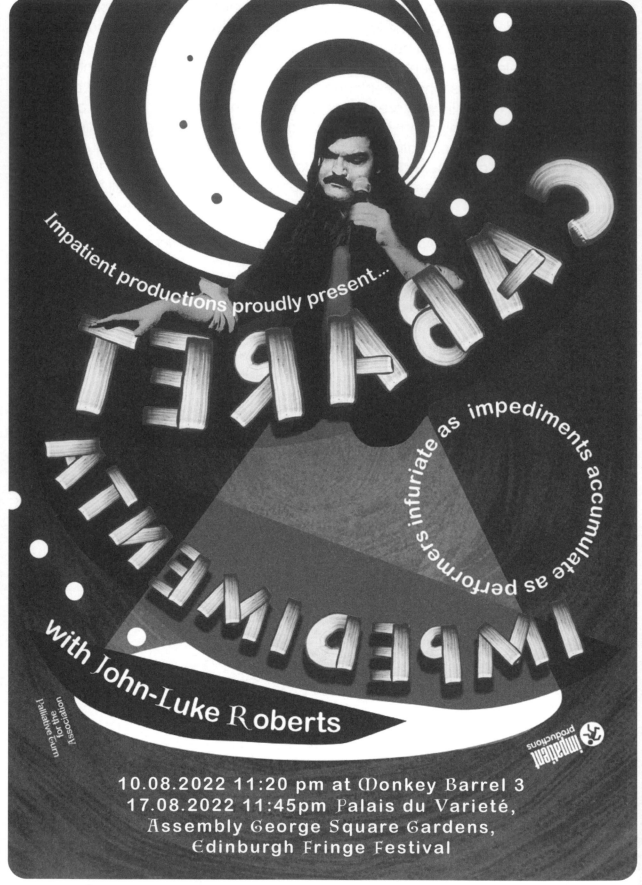

Poster for APT's Cabaret Impedimenta at The Edinburgh Festival Fringe 2022,
designed by Kasia Fudakowski and Bernd Grether, 2022

PLÄSNT DSCHÖRNIE

MOVING FLYER

* * * * * * * * * * * OUR DRIVERS ALWAYS BLOW

.00 — GUARANTEED * * * * * * * *

★ ★ ★

WE'VE INTERVIEWED*
OVER 100% OF OUR
SATISFIED CUSTOMERS
AND THEY GIVE US
3 OUT OF 3 STARS —
ALL OF THE TIME:

★ ★ ★

★ ★ ★

★ ★ ★

★ ★ ★

Thus, we love to hear your feedback, your recent experience with us will take only 1 minute to complete.
THANK YOU

Share Your Feedback
ROOM CALCULATION PROCESSOR INFORMATION

CLIP ✂

Property Of:

WITH RESPECT & REGARD

& PASTE

NEED HELP GETTING PACKED UP?

For convenience, no guesswork – just substantial feelings, a space of lightness, cool skin, warm breath, calm views, soft strides

Nervous? before try out! the move

·MUSTY + MUST-HAVE·

HERBAL CALMATIVE
Helps relax tensions for a good night's sleep, and a good mornings move!

100% 3.00 250% 6.50

♦♦♦

DO NOT lose hope! We realize that even the most chilly of moves requires a hearty hand on the hip, which we provide! In all cases!

ALWAYS feel free to call us for a consultation when your friends, or, and family flake out and leave you high and dire at the epicenter of a terrible move! We won't be late!

ALWAYS use only the accessories that are recomended by the movers on hand for your move! Use of accessories that have been designed for use with other moving companies could result in serious injury!

DO NOT leave any foods inside of the fridge! No matter how hungry you are, or might be soon or later!

ALWAYS forget that above all, you are not alone, even if you have no one to help you pack your collections and projects! That's where we come inside!

DO NOT forget that if you have a lot of books or bags of lentils, don't put them all in one big box! It might break! This a bad thing!

DO NOT beat yourself up! A nice rest before bedtime will leave you with a warmpth inside where once was a frostration outside!

ALWAYS sweat may be stinky but it's still sweet! In a fact!

Pre-Move Safety Procedures

Further Usage Information available on request

ROOM CALCULATION PROCESSOR

XG = x-greet/x-garge/x-grand/x-grande

G = greet/garge/grand/grande

M = middel/medium/moyen/media

S = snug/small/suite/spiccola

Quick Facts: Estimate the overall scope of your move with the pocketable size guide we provide here (above).

INSTRUCTIONS FOR USING

The applicable limits of this tool for preparing for a move (this is, of us, helping), are as follows:

1. There are no true limits to how many rooms you can or should measure with this handy tool we prepared up for you, so please, have a good time and enjoy the process - we made it fun.

2. Cut the calculator from this page with scissors or the knife and hold loosely at arm's length. Line up each wall with a tick mark on the calculator and note in a small note book or note pad. Continue rotating in place until you've finished and measured every wall in your home. When finished, send us the results for a nice price.

If your move also involves carrying of animals, large

example:

ᚻealth ᗞata

Keith Larson

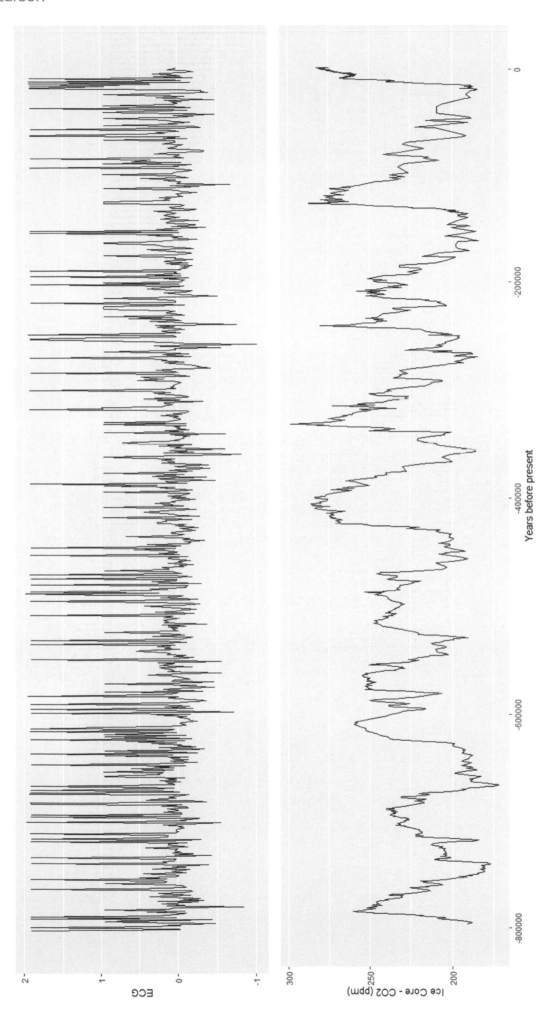

Ꚍop: ᚋormal 5-day electrocardiogram of a healthy adult
Bottom: Ꚍhe evolution of average temperatures over the past 800,000 years as determined by analysis of the Vostok ice core.

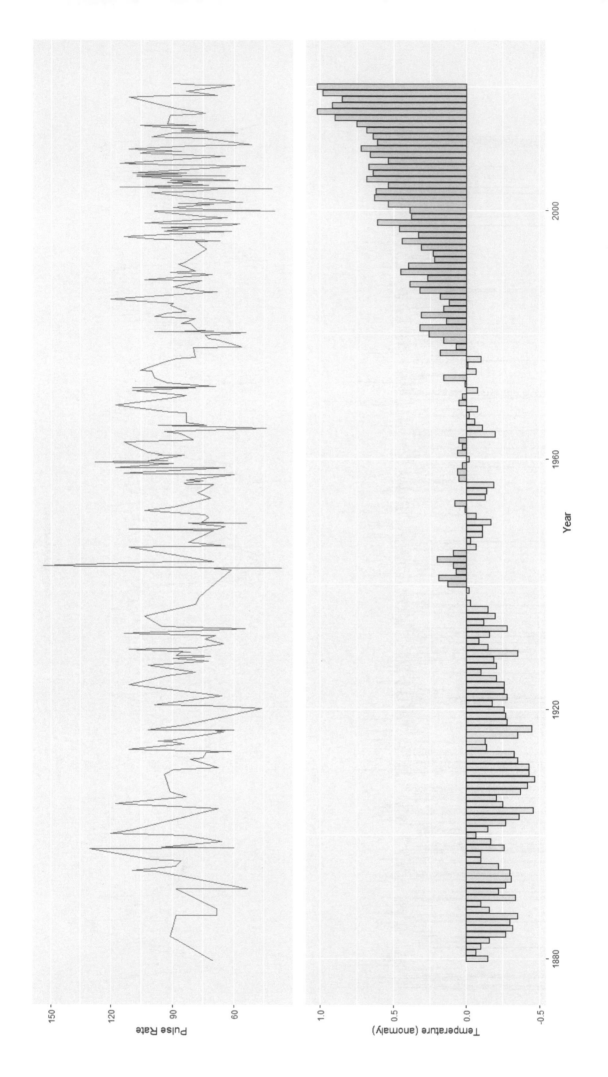

Top: Normal 5-day electrocardiogram of a healthy adult.
Bottom: The so-called Keeling Curve, which shows the evolution of atmospheric carbon dioxide concentrations since 1985 (measured at Mauna Loa Observatory).

14

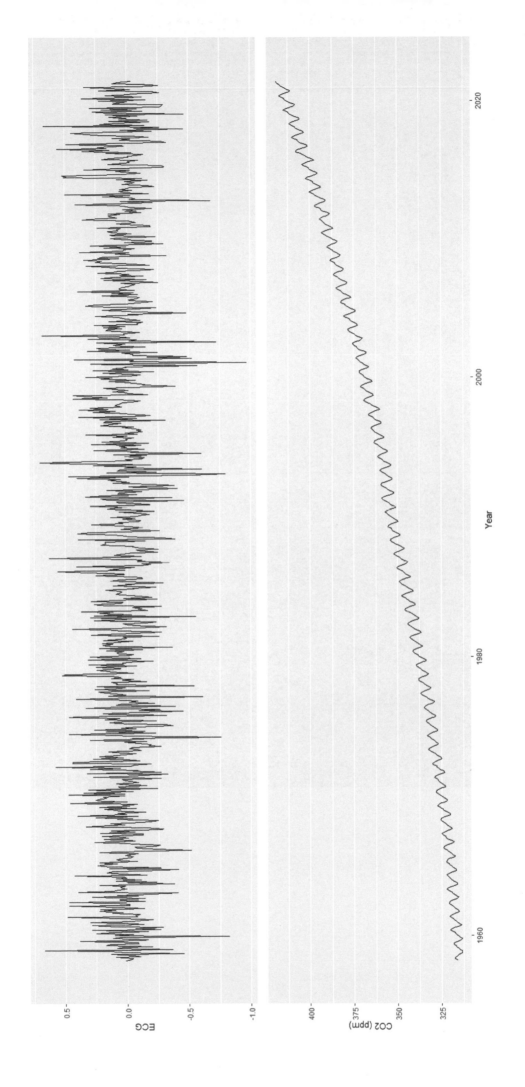

Top: Normal pulse rate diagram of a healthy adult,
Bottom: Diagram of global temperature anomalies from 1880 to the present.

(15)

Marit Neeb, Source material for *Flaschen*, 2020 — ongoing

Thoughts on *Flaschen*
Marit Neeb

The East German authorities didn't allow me to graduate from a secondary school that would have enabled me to study at a university. Because of my family, a bit of collective punishment, if you will. So my only option was to get a vocational education—people without one were the dregs of society and branded as criminals. In a gesture of protest and an intentional effort to play a creative game with even tighter constraints, I applied to a retirement home to become an occupational therapist. This was just before the Wall came down, the country was in agony anyway, and I thought that made perfect sense. My mother mounted the barricades right away. Being a doctor, she knew that given the staff shortages I'd effectively be a geriatric nurse. No matter—there was a single slot per district in Berlin, and I didn't get it.

Then there was the HO WtB Berlin, a large state-owned retail business selling essential consumer goods, in whose advertising division I trained as a commercial graphic artist. The programme was a holding cell for all those who weren't allowed to enrol in art college. We were a motley crew. And there was a whiff of alchemy to it, like turning shit into gold. Because of the scarcity of materials and tools, we became inventive and skilful with our hands. It wasn't until much later that I liked to imagine there'd even been a bit of a Warhol vibe in the air.

I did study art later on. My professor told me I should also paint for a change, and for a brief period I did. Mostly monuments and Russian officers' gravestones with giant radiotelephones. Then he said I should be my own motif, and as a nude, that would be much more interesting. I thought that was silly and unmodern and swerved sideways, into another department. For lack of better options and by chance, I once again ended up with the designers. Everyone was younger and on a first-name basis, very much unlike the masters and their disciples. I concurrently took classes in product design, cradle to cradle, materials research, and so on. Looking to the West as before, also when it came to music.

The PET water bottle is perfect for me. It offers me what I like and need: form, rhythm, repetition, and movement. It's in daily use all over the world yet old, too, even a bit like a torso. Its body is moulded out of greed. With a skin of patterns and symbols. Its content is the elixir of life.

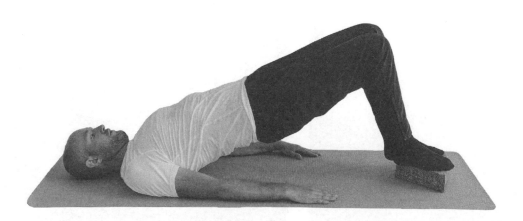

Put your feet on a Palliative Pilates block and raise your hips as far up as you can. Stay in that position for a while and lower your hips again. Repeat ten times.

REPORT AFASIOTOPIA* — The First APt Symposium at Salon am Moritzplatz, Berlin

This initial gathering took place from 18 to 20 September 2020 at the Salon am Moritzplatz in Berlin before APt was even named. Hence the curious title. It was motivated by a simple question: What would happen if we began to think of art as a practice that helps us leave this life behind? A process and a method that prepares us for the fact that individually and as a civilisation we will cease to exist in this specific form rather soon? In a three-day symposium a group of artists, scientists, comedians, medical and palliative professionals tried to lay the groundwork for the declaration of the Palliative Turn in art. The symposium comprised internal seminars and conversations on topics such as climate science and palliative medicine, it included kinesiology treatments, performances and shared meals and concluded with a public event with various performances and presentations and even an impromptu, interactive theatre rehearsal.

With Annemarie Goldschmidt, Kasia Fudakowski, Dafna Maimon, John-Luke Roberts, Simon Blanck, Lars-Erik Hjertström Lappalainen, Keith Larson, Lydia Roeder, Olav Westphalen

*A Foundational and Speculative Invocation of the Office of Palliative International Art

John-Luke Roberts and Kasia Fudakowski at AFASIOTOPIA, photos: Simon Blanck

Palliative Pilates – Exercises throughout the Publication
Simon Blanck

Palliative Pilates (sometimes referred to as Palliates) is a new form of core and flexibility exercise. The thing that sets Palliative Pilates apart from regular Pilates and other core and flexibility exercises are the special type of Palliative Pilates blocks used in all the positions. The only rule of Palliative Pilates is that you keep some kind of contact between your body and one of the Palliative Pilates blocks at all times. Below is a guide to some of the most basic positions of Palliative Pilates so you can do Palliative Pilates in the comfort of your own home.

Palliative Pilates blocks are pieces of discarded tombstones. When burial rights run out and are not renewed (usually they last for twenty-five years), a tombstone will be removed—unless it has some cultural or historic value. The removed tombstones are then transported to a crushing facility and made into landfill. To make the transport easier the tombstones are partially destroyed at the cemetery, and it is in this state they can be used as Palliative Pilates blocks. Cemeteries usually pile up quite a few of them before they are transported. Get in touch with your local cemetery and go and try out which blocks fit you. They will happily give you some of them for free. For the exercises described here you will need two Palliative Pilates blocks.

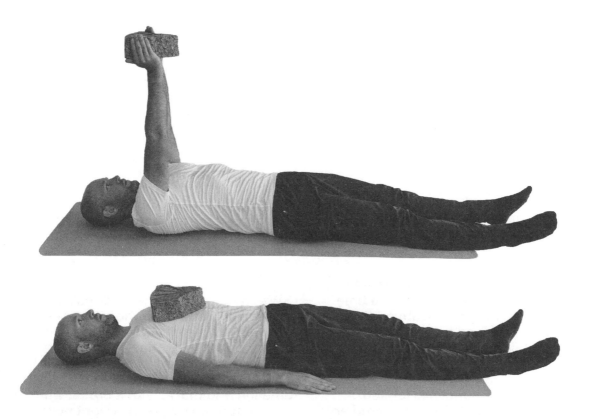

Lie down on the mat and stretch your arms above your head, grab the Palliative Pilates block, lift it over your head and hold it in your outstretched arms for a while. Then lower your arms and put the block on your chest and let it rest there for a while. Then lift it up again, and put it back above your head. Repeat five times.

REPORT
Lydia Roeder's Workshop on Palliative Care

In October 2020, during the first gathering of those who would later found the Association for the Palliative Turn, Lydia Roeder spoke about her work as a palliative care specialist. She outlined the principles of palliative care and described some practical, medical, and ethical aspects of her field. The information she provided directly influenced the jointly written 'Call for the Palliative Turn', the founding statement and manifesto of the Association for the Palliative Turn (see pages (44/45))

As one of a number of exercises she presented, Lydia asked her audience to each draw a timeline. You can experience this exercise too, by following the instructions, and drawing in this box.

Lydia Roeder during AFASIOTOPIA at Salon am Moritzplatz, October 2020

Step 1
Draw a timeline. As long, short, and in whatever shape you like.

Step 2
After everybody had drawn a timeline, Lydia instructed them to mark the time of their birth and their death on that timeline. Now you can mark your birth and death on your own time line as well.

The individual timelines looked dramatically different. Some covered an average human life span, others seemed to extend through historical, even geological time, with the individual's life being reduced to a minute speck. Others, rejecting diagrammatic convention, were shaped like circles or spirals instead of straight lines.

Step 3
When Lydia gave the final instructions, a groan went through the room. Whatever smug smiles might have been on the faces of the wittier ones, who had so cleverly refused to accept linear time, disappeared. Lydia said, 'Look at your timeline and mark, with a cross, where on that timeline you are right now!'

Some of the slides of Lydia Roeder's presentation are reproduced here.

Palliative Care

provides relief from pain and other distressing symptoms

affirms life and regards dying as a normal process

intends neither to hasten or postpone death

integrates the psychological and spiritual aspects

offers a support system to help patients live as actively as possible until death

offers a support system to help the family cope during the patients illness and in their own bereavement

uses a team approach to address the needs of patients and their families

including bereavement counselling, if indicated

Skills of Staff

empathy

communication

organizing ability

dealing with borderland

courage to make decisions in borderline situations

capacity for teamwork

tolerate the tension between autonomy and provision

Assessment Form for the Association for the Palliative Turn

Item under assessment: _____

Date: __ / __ / ____

APT guide (where present): _____

Assesor: _____

Relationship to item under assessment: _____

1. Does it make you feel warm?

2. Does it provide relief?

3. Does it acknowledge the existence and inevitability of the end?

4. Does it affirm life and regard dying as a normal process?

5. Does it intend neither to hasten nor postpone the end?

6. Does it integrate physical, psychological, and spiritual aspects?

7. Is it courageous in taking a position in crisis situations?

8. Where possible, is it supportive of an active and fulfilled existence until the end?

9. Does it not only enhance the quality of life, but also demonstrate the potential to influence the course that life might take?

10. Is it non-hierarchical?

11. Is it communicative?

12. Is it collaborative?

13. Is it empathetic?

Score guide:
1 - No, I strongly disagree
2 - No, I disagree
3 - Undecided
4 - Yes, I agree
5 - Yes, I strongly agree

TOTAL:

Scores between:
13-39: Not palliative at all
40-52: Quite palliative
53-65: Extremely palliative

Assessment form designed and developed by Kasia Fudakowski between 2021-22

Know That Hello Also Means Goodbye — On Trying to Be a Palliative Artist

Dafna Maimon

When Olav Westphalen called me in the summer of 2020 and asked if I wanted to be part of a new association around palliative care and its connection to art, I enthusiastically replied: I'd love to! I love cave people! I had just been reading a few books on Upper Paleolithic cave art and was eager to have a group around the research. We continued speaking, mostly on top of each other, with squealing eagerness; I about cave paintings, and their inherent cooperation with the natural environments they are found in, as a new foundation for considering art-making; Olav about conversations he'd had with climate scientists on contemplating the planet as someone who is dying, and may be in need of palliative care (and artists, perhaps, being the least likely saviours thereof). Despite our semiotic confusion, and essentially, the laying out of plans for forming two entirely different groups, we were somehow already speaking of the same thing. A few months later The Association for the Palliative Turn (A^P_T) was born.

Four years earlier I'd begun collaborating with Ethan Hayes-Chute on our ever-growing Gesamtkunstwerk, *Camp Solong*. The process-oriented project lives on a sister planet to A^P_T. While it is not directly a palliatively framed undertaking, *Camp Solong* is a nomadic summer camp for grownups who 'Stay to Leave' and, 'Where Goodbyes Are for Everyone'. Our camps are heterotopic spaces: each session gives six people over the age of 25 the possibility to return to a childlike existence of campfires, outdoor sleeping (in bunk-beds), scheduled naps, and talent shows, all while processing amassed losses and hang-ups clouding their lives. The campers, selected via open call, each describe in their application letter what kind of loss they are hoping to process or achieve (in the event that they are letting go of something) during the three-day camp. However, it is not a retreat for grieving nor an ordained therapeutic programme; the camp counsellors are two artists— Ethan and myself. Throughout the camp we embody our ridiculous, (and by now middle-aged) yet seriously playful alter egos Fluffy & Baloo, who are driven by an exaggerated obsession with farewells.

From the very beginning of the camp the focus is placed on its end. In fact, the camp's first hour is spent on an exercise called The Goodbye Hour, in which the campers practice saying goodbye to one another before even introducing themselves. This reversal of attention, from essentially hello to goodbye, serves as a way to embrace life and build intensity of the moment:

> At *Camp Solong* we have asked ourselves time and again: What exactly makes the stakes so high? Why do we feel so much at Summer Camp, and how can we feel it best? Why does the experience stick so hard? The answer: because it ends. Every Summer Camp starts with its end in sight, and at that finale, every camper, every counsellor, has to face this inevitable separation from something that will never be again.—Extract from *Camp Solong* Brochure

Palliation means to embrace, or cloak, and within palliative care, it is to ease a dying person's pain. *Camp Solong's* focus on goodbye as a mantra channels the idea of any human life as one that is in the process of dying, and therefore in need of palliative care. It also considers mourning as a never-ending process, one that follows you around like a fluctuating shadow, only appearing differently at times, depending on one's relationship to the light. Perhaps it is similar to believing in a slow apocalypse already in effect, rather than an unforeseen meteor smashing into Earth, or a jumpy finger hovering over a button, ending it all in one go.

Each camp session is, in a way, a simulation of a life within a life, where the desire is to make the most of each day. The campers are asked to rename themselves with a camp name that could awaken good feelings, aspirations, or perhaps help nudge some frequent bad behaviour in another direction. In one of the sessions a late-rising camper took on the name Early Bird, while another struggling with familial acceptance of their sexuality chose Queen Elizabeth. Ethan became Baloo via an exercise in acceptance to take suggestions from others, and I became Fluffy due to an unending, irrational joy upon imagining any creature with that quality. The new names allow for the reconstruction of an identity, within an otherwise non-gendered, homogenised camp wardrobe of sunset hues and soft cottons.

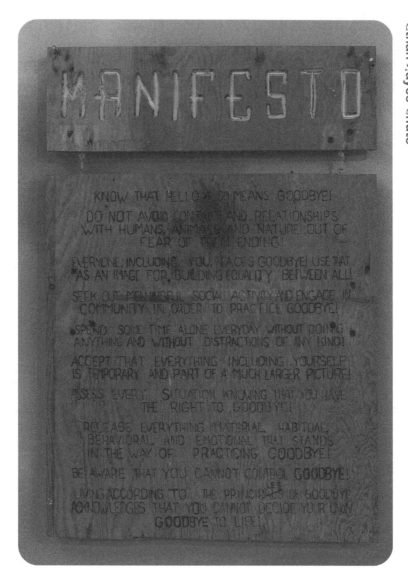

Dafna Maimon & Ethan Hayes-Chute, *Camp Solong*, *Manifesto*, 2016, photo: Ethan Hayes-Chute

While endings and goodbyes are a trademark of *Camp Solong*, they are still approached with equal amateurism by its camp counsellors as by any layman who'd rather avoid the thought of one's days being numbered. For A℗G's exhibition at the Künstlerhaus Bremen, we invited viewers to experience an intimate moment from the camp counsellors' personal life. Our installation there, *Camp Solong: Sheltered Hangups*, is a makeshift, private fort, constructed with blankets thrown over a table that one can crawl under (if meeting the requirements to enter, which are stated on the dangling sign above the entrance: Grown Ups Only). Once under the table, the viewer finds themselves in an altered space; a mini-cabin of sorts, built around a resting place, containing private items and notes, and a peach-coloured landline telephone from bygone times. By picking up the receiver one can eavesdrop on an ongoing conversation between Fluffy and Baloo. The counsellors are heard finding one way after another not to say goodbye, and instead, just hang on the line by passing the ball of goodbye back and forth.

While ᴀᴾᴳ as an association borrowing from and referring to palliative care asks questions around how to live as warmly and fulfilled as possible till the end—once an end has been diagnosed or acknowledged—*Camp Solong* imagines itself creating simulations of how to live meaningfully throughout life, in the unknowing state of when and where one's end will be. As such, *Camp Solong* does its best to make sure that the end is never out of sight, and therefore as a belief system it could be seen as being more neurotic. After all, is obsessing over the end really accepting the end? Somehow, it speaks of distracting coping strategies, and a general lack of trust in life. Never living a day without assuming it could be one's last is an approach that is neither sustainable nor, ironically, very present. As a project mythology then, it seems to inhabit some kind of trauma mediated by self-deprecating humour. And yet, each fleeting day never feels as deeply rich, hilarious, and warm as it does at *Camp Solong*.

Knowing my own biography, and how it always feeds into my work, it is no surprise that *Camp Solong* both engages and performs some form of trauma. My 44-year-old healthy father inexplicably disappeared from my life when I was 13—from one day to another gone—somehow dying of what may have been a simple fall down the stairs. Ever since then I have felt that my life was conditioned by this event, his end. The resulting non-linear and continuously oscillating mourning (the rhizomatic trauma of unprocessed loss) is still floating around like almost-invisible yet disturbing spring pollen through my family's existence. In a way, *Camp Solong* has been the one project that in part (at least on my end) started from wanting to explore the experience of loss. It simultaneously also ended up being the one to soothe this injury substantially. It makes sense that *Camp Solong* is ongoing (for six years now) and follows an unpredictable schedule; like grieving, it has no expiration date and no set rhythm.

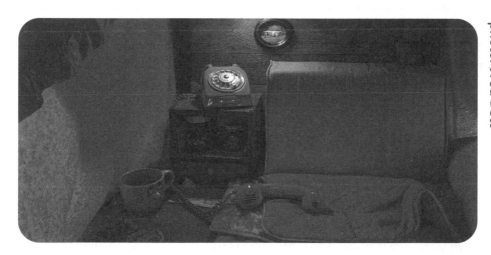

Dafna Maimon & Ethan Hayes-Chute, *Camp Solong: Sheltered Hangups*, 2022, installation view Künstlerhaus Bremen 2022, photo: Fred Dott

When Ethan and I submerge into each *Camp Solong* session, we do not build a cabin as a sculpture to be seen from afar, or just plan a fun, performative programme, we make a liveable, brief fictional world, in which we open deeply to the temporary community that forms through the unique symbiosis of its members. *Camp Solong* couldn't exist without its campers, who arrive at the camp with just a toothbrush and a piece of 'emotional trash' in hand, and let go of everything else: their regular clothes, their phones and computers, their names, the knowing of what will happen each day, and any contact to the outside world. At the end of the camp, and especially during the last evening, when the Emotional Trash is brought out and its backstory shared with the group, the unending scope and universality of loss (and shared tears) is rarely as viscerally and warmly felt as then.

Once ᴀᴾᴳ got up and running, I was riveted to be one of its founding members. The work Ethan and I were doing with *Camp Solong* could now be supported by a bigger family of thinkers, artists, bodyworkers, and palliatively curious humans, circling around questions arising when facing life-endings. And indeed, a year after joining ᴀᴾᴳ, and having had

the chance to learn from actual palliative care workers and collaborate on these topics with the association's members, the new knowledge already had an effect. It supported me in accepting having to say goodbye to a dear friend who didn't survive his fight against cancer. Then, early this winter, I found myself in a newly excited place in relation

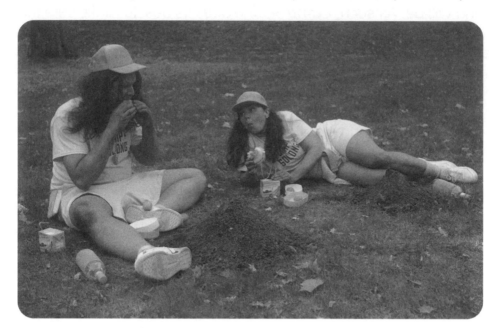

Camp Solong: Losing Weight,
2021, video still

to these topics; I was to bring new life into the world by the end of the summer, and would suddenly be moving towards birth rather than the opposite. However much my previous obsessing about the unknowingness of the end, and even my training for unpredictable goodbyes through *Camp Solong* could have prepared me, it was still to my utter shock that I lost the child I was carrying in its second trimester. For a moment then, it seemed that no previous work, no *Camp Solong* manifesto, with its warnings and pre-emptive attempts at accepting life's goodbyes, no A_G^P workshop or event, could help me out of the despair I found myself in. After some weeks of life getting really dark, I went to see a former therapist who simply told me that there was no way to cover mourning through insurance; mourning was not a diagnosable illness. He further elaborated, when I worried out loud about not being able to meet my work obligations, that while what I was going through was unfortunate, and undoubtedly painful, I was not sick—it is society who is ill.

While all this was happening, there were opportunities to plan a new *Camp Solong*, as well as participating in A_G^P events and future exhibitions. While most likely avoiding the deeper pain that was actually gripping me, throughout that time I worried gravely about falling behind and being left out of A_G^P (despite reassurances that it was more than OK to take a break). Only months later, when time and the sun had restored life a bit, did I see how absurd it had been to feel guilt and to experience 'FOMO' for not being at peak performance as a member of a palliative association during a period of physical healing and mourning.

Perhaps it may take many more *Camp Solong* sessions, even more training in saying goodbye, more A_G^P events, workshops and retreats before I can call myself a palliative artist. It may even be possible to convince myself, in good neoliberal logic, that additional losses make for a better *Camp Solong* counsellor. But, instead, I prefer writing this text, and re-watching our own *Camp Solong* instructional video *Losing Weight,* and let Baloo remind me, that sometimes, all one needs to do is dig a hole in the ground with a friend, scoop out the dirt with your bare hands, and then life may feel just that much lighter.

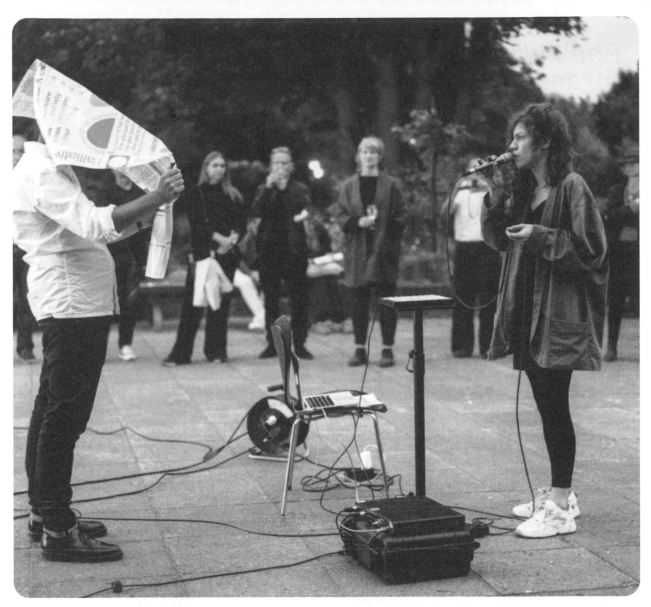

Nala Tessloff, Performance of *Manifesto* (composed by Nala Tessloff), Brandenburgischer Kunstverein Potsdam, 19.08.2021, photo: Simon Blanck

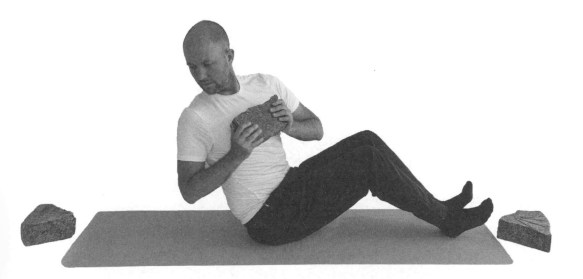

Sit up with your back and legs straight and hold the Palliative Pilates block in front of you with straight arms. Then bend your legs slightly and pull the block to your chest and do a Russian twist to your right and to your left. Then go back to the starting position. Repeat ten times.

REPORT
The Palliative Turn at Brandenburgischer Kunstverein Potsdam

In the autumn of 2020, Gerrit Gohlke, the director of the Brandenburgischer Kunstverein Potsdam, invited the members of ᴀᴾᴛ to exhibit in the Kunstverein's small but iconic gallery, a free-standing, modernist glass pavilion on the Freundschaftsinsel (Isle of Friendship), surrounded by a lush, educational garden, a recognised cultural monument. This was ᴀᴾᴛ's first institutional exhibition, and it required the members to consider, in practical and concrete terms, how to make what they were doing public.

they were doing. The show comprised art objects and events that were clearly recognisable as art, but it also included a number of non-art objects and processes that didn't fit comfortably in the context. An elaborate schedule of live events and conversations pointed towards things and experiences that can't be exhibited without becoming relics or mere theatre.

Participants: Simon Blanck, Kasia Fudakowski, Anna Gohmert, Annemarie Goldschmidt, Ethan Hayes-Chute, Lars-Erik Hjertström Lappalainen, Per Hüttner, Alex Kwartler, Karin Kytökangas, Keith Larson, Mathias Lempart, Dafna Maimon, Nala Tessloff, Carima Neusser, Nina Katchadourian, Michael Norton, Rattelschneck, John-Luke Roberts, Xavier Robles de Medina, Lydia Roeder, Carola Uehlken, Olav Westphalen

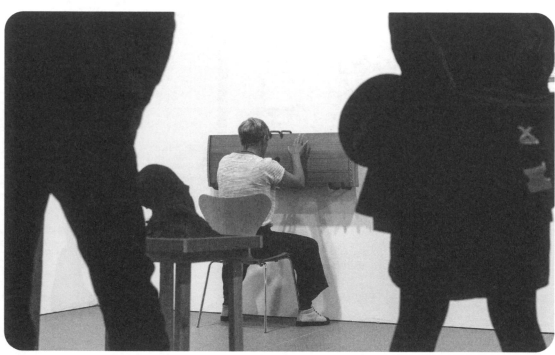

Lydia Roeder demonstrates the Körper-Tambura, an instrument designed to be played on the body of palliative patients who are no longer able to receive physical massages. Photo: Brandenburgischer Kunstverein Potsdam / Michael Lüder

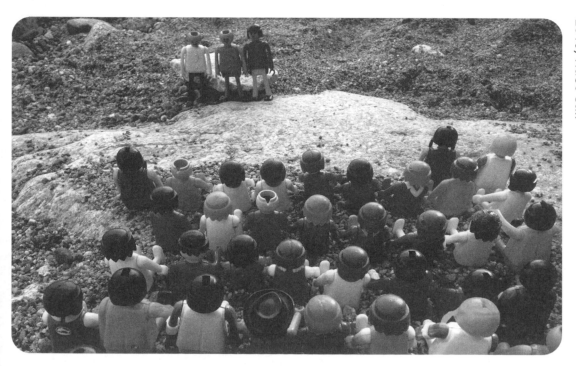

Nina Katchadourian, *The Recarcassing Ceremony*, 2016, video still

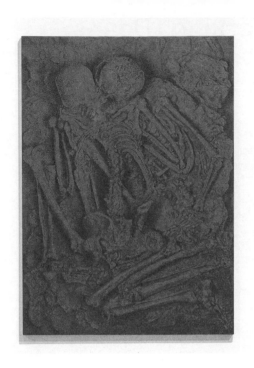

Xavier Robles de Medina, *The original position of the skeletons from the double burial from Grotte des Enfants. Upper Paleolithic, Italy, c. 24000–20000 BC*, 2021, photo: Simon Blanck

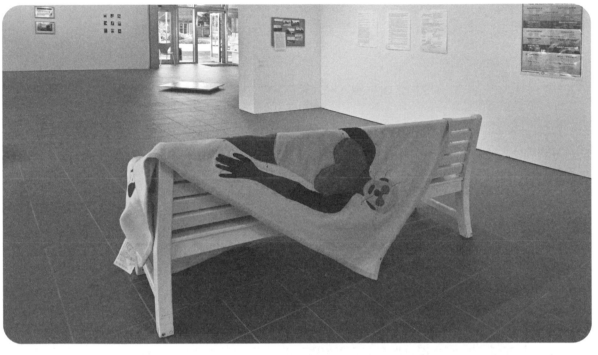

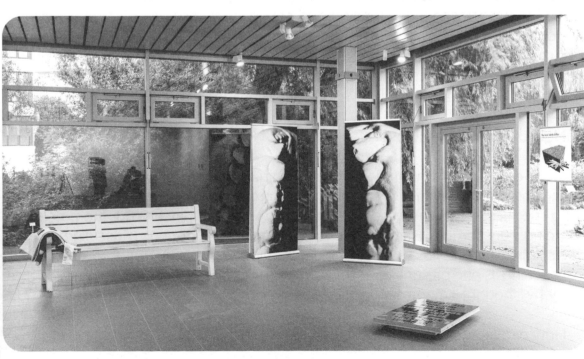

Exhibition views Brandenburgischer Kunstverein, Potsdam, 2021, photo: Brandenburgischer Kunstverein Potsdam/Michael Lüder

The Association's Way of Working Means Less Progress Than Process

Marit Neeb and Nadja Quante

Laura Pientka, *Gender Blossom*, 2022, photo: Frederik Preuschoft

Nadja Quante (NQ) is the artistic director and curator of Künstlerhaus Bremen.

Marit Neeb (MN) is an artist and worked at the Brandenburgischer Kunstverein in Potsdam during the exhibition *The Palliative Turn*, in summer 2021.

NQ What was the starting point for the exhibition at the Brandenburgischer Kunstverein in Potsdam? How did it come about?

MN The exhibition and events at the pavilion on Freundschaftsinsel meant the maiden voyage for A℘T. Its starting point was the trust of a long-standing friendship between Gerrit Gohlke, the artistic director of the Brandenburgischer Kunstverein, and Olav Westphalen. During the founding process of A℘T, Gerrit was also partly involved through meetings and workshops via Zoom. A℘T came to Potsdam with a collection of very different material and diverse ideas for artworks and performances. On site and in cooperation with the association, an exhibition and series of events with 22 broad positions was put together. On the occasion of the exhibition, a large, foldable poster was created which included the manifesto, text contributions specially written by participating artists, and an exhibition text by Gerrit. Every participant also responded to four questions about their understanding of the term 'palliative' and the intentions of the A℘T.

MN How did you come across A℘T's activities?

NQ I came across the project through Dafna Maimon in the summer of 2021. I found the idea of inviting A℘T to the 30th anniversary of the Künstlerhaus interesting—to focus more on upheavals than permanence. Since 2018, the process of renaming Künstlerhaus Bremen due to the problematic generic masculine noun in the institution's name has been ongoing. Meaning that Künstlerhaus Bremen is also approaching its end as Künstlerhaus Bremen—at least I hope so. These were the reasons why I thought it made sense to invite A℘T to realise a project at the Künstlerhaus.

MN How did you go about preparing for the exhibition with such a large, disparate group?

NQ In the curatorial process, I was primarily in contact with Olav Westphalen and Kasia Fudakowski. There is a loose agreement within the group that whoever receives an invitation, or establishes a relationship with an institution, can secure funding and take the lead in curating that opportunity for APC.

An open call was sent out to all members asking for contributions for an exhibition and events programme at Künstlerhaus Bremen, and a connection was made (via Zoom) with Oliver Meyer, vice president of the German Society for Palliative Medicine, who was planning their congress in autumn 2022 in Bremen. He had already been involved in Potsdam.

The selection from the open call took place in consultation with Kasia and Olav. Some works were produced specifically for the exhibition in Bremen, such as the buffet of hybrid seafood by Jana Thiel and Volker Grahmann, the moulded butt by Laura Pientka, the work *Camp Solong: Sheltered Hangups* by Dafna Maimon and Ethan Hayes-Chute, the oversized beach ball by Karin Kytökangas, and of course the site-specific palliative assessment of the Künstlerhaus Bremen by Kasia. We also selected some works that had already been shown in Potsdam, such as Per Hüttner's drawings and Mathias Lempart's riddle signs, presented in the court-yard. And then, there was the wall piece in the stairwell to the Künstlerhaus gallery, which was an APC intervention, designed by Mati and Sascia of Shortnotice Studio, who design APC's visuals. They designed excerpts from the APC manifesto for the staircase and entryway.

Per Hüttner, *Duet with a Dying Plant*, performance view, Brandenburgischer Kunstverein Potsdam, 21.08.2022, photo: Jo-Hendrik Hamann

The constellation of works by Gernot Wieland, Carla Ahlander as well as Lars-Erik Hjertström Lappalainen was proposed collaboratively. I had sent Gernot the open call because I knew that there are shared interests and friendly ties between him and APC. The contributions from the students of the Hochschule für Künste Bremen are due to Olav's professorship there, but also to a course he held in 2021, which was titled 'Aesthetics of Decay'. In the end, all contributors ended up on the list of artists, regardless of whether they contributed to the exhibition, the event programme, or the magazine. This was done in a similar way at the Brandenburgischer Kunstverein, and I find it very characteristic of the project.

What do you think are the differences between the two APC exhibitions at the Brandenburgischer Kunstverein in Potsdam and at the Künstlerhaus Bremen?

ON The formats are somewhat different. In Potsdam there was a very extensive, collectively developed accompanying programme with a total of nine events, consisting of concerts, workshops, performances, lectures and talks. What was interesting for me was that they were so very different. The heterogeneous, inclusive and open nature of APC was also reflected in the performance programme. Beautiful lines emerged through the

inclusion and effect of the location, the glass pavilion on Freundschaftsinsel. Nala Tessloff's ethereal singing was carried outward through loudspeakers and captivated the pass-ers-by, Carola Uehlke's car tour through the city, which was rather dark in terms of content, nevertheless had such a paradisiacal starting point, and Dafna and Michael's workshop found its character in the greenery; the loaction played a role. Per Hüttner's dialogical performance with a plant dying of thirst once again took on its own dimension in the historically significant garden. So for me, the joining element came about mainly through the external circumstances. In retrospect, I find this as peculiar as it is interesting, that a place is much more than a stage, but also a protagonist.

As the occasion for our conversation is the publication, it occurs to me that a big difference was also thinking about an accompanying medium in print format in parallel when planning an exhibition. Artistic contributions in text and graphic form can be found in the publication in Bremen, but were still integrated into the exhibition space in Potsdam. Another difference was the collaboration with the institution, which became more inter-twined in Bremen, for example through the wall work with fragments from the A^P_G mani-festo. I think that's great, and some of the contributions have the potential for exciting and playful serial iterations that might evolve within A^P_G.

ꟽꞂ How did you perceive the exhibition in Potsdam? Did you sense, perceive or en-joy the special nature of A^P_G?

ꞂꞐ I was a bit overwhelmed at first. I had very little time to look at the exhibition after the event I had come to, and to really perceive many of the contributions, which often meant reading them. To me the exhibition seemed partly like a book, because there were a lot of text and text-image constellations. For me, there were a lot of individual, very diverse contributions. For Bremen, I then felt strongly about bringing out more of the connections between the individual positions and putting together a more sensory, less text-based, exhibition.

I think it is extremely important for A^P_G members to have repeated opportunities to come together and spend time together to exchange ideas. Only through these gatherings can there be more and more awareness of the interplay between the individual positions and more collaborative work.

ꟽꞂ Yes, being together to come up with solutions and implement them is not only important for A^P_G, but almost a requirement. The starting point for A^P_G's way of working is a clearly formulated motivation in the form of a manifesto, initiated by Olav and the first comrades-in-arms, some of whom have been friends for some time. So, there is a cata-logue of theses and questions, as well as a series of individual articulations in texts and works, but all this is then also open to debate and revision. This methodology has its own beauty; however, this may not necessarily manifest itself immediately and explicitly for the audience in the exhibition space or in individual performances. Whether it can be read from the outside by the audience, I can't say. Maybe you can say something more about it?

Despite the shared manifesto, the development of the activities of the group are organic, non goal-oriented, and unforeseeable. A^P_G's way of working therefore means less progress than process. And perhaps that is precisely what is palliative for me.
I think it has, above all, a workshop character. The workshop, however, is not particularly tidy and well-organised, but rather characterised by, at first glance, idiosyncratic collec-tions of materials and wild working corners. In addition, it does not have a fixed location and is not evenly lit due to the geographically distant, different lives of the participants. But perhaps these characteristics of A^P_G also necessitate an open, temporary, provisional way of operating.

NQ I do wonder how APE's collaboration with institutions can be palliative and sustainable in the long run. I don't want to complain, because it has been a lot of fun, but it's a very costly and labour-intensive process to work with such a large group. It was quite challenging for our small exhibition team. It was a great gift that the team was able to support this effort because they were also excited about it. The only question is: Is APE's way of working palliative? And what might palliative collaboration mean?

MN I agree with you. It is very labour intensive, but with that, it is probably already palliative. If you assume that the palliative, in the medical sense, also includes, initially, many small and laborious procedures and processes—in this case, they have to be repeated without interruption on a daily basis. But it is also palliative in the sense that I have rarely laughed so hard until my stomach hurt while working in the art business, which is usually more focused on efficient and solution-oriented results. Especially about our own lunges or missteps. The staggering of such a circular motion is certainly not easy to cushion for institutional structures either. Things have to be worked through. You have to move forward.The process promotes empathy and leaves room for the most diverse personalities, and it allows causalities to become more conscious with each other.

NQ What do you think could be the future of APE?

MN My current and very personal advice would be spending time together. Lying on your back and between pillows, no matter if you are exhausted, in pain or lazy. Active in so far as you talk and laugh with each other and thus open up free space and gain thoughts. But that is, of course, also an incredible luxury. Time is so precious. Our shared time—that of the earth—and that of each of us.
 Do you have any thoughts or suggestions for future steps for APE?

NQ I think a retreat or camp and definitely more issues of this journal would be a good step.

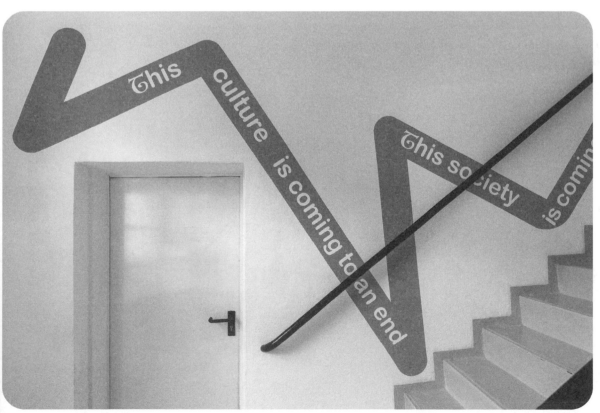

Shortnotice Studio, APE Manifesto, installation view Künstlerhaus Bremen, 2022, photo: Fred Dott

Drawing: Nadja Quante, photo: Frederik Preuschoft

REPORT
The Unspoken Consort, Concert at Brandenburgischer Kunstverein Potsdam

For their programme *Moro, Lasso,* the Unspoken Consort chose a selection of emotionally charged renaissance compositions. In hindsight we know that these works all have violent or tragic backstories. With great care the musicians reveal parallels between these works, the conditions of their creation and contemporary reality. The subtlety and beauty of the historic works remain, even though they are couched in narratives of murder, sexualised violence, and oppression. Sorrow and grief over past and current pain coexist here with consolation and care. With Emilia Durka, Annalouise Falk, Hans Fröhlich (recorder), Tommy Fields, Alma Stoye, Anna Lodone (viola da gamba), Nala Tessloff (vocals, text).

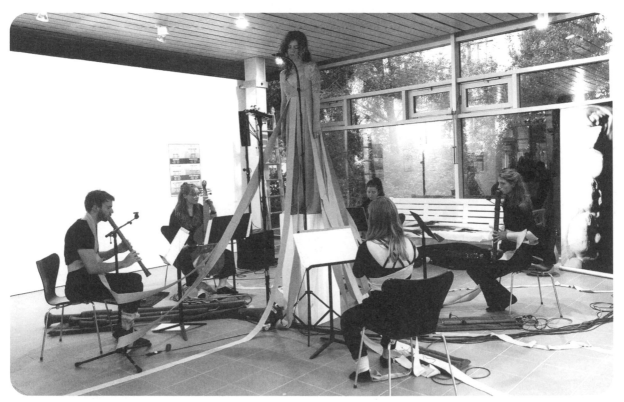

Photo: Jo-Hendrik Hamann

REPORT
An Evening on The Palliative Turn at KW Berlin

At the invitation of Sofie Krogh Christensen, *An Evening On The Palliative Turn* was conceived and hosted by Kasia Fudakowski with members of the A𝘱T at KW Institute for Contemporary Art's Pogo Bar, Berlin on 10 March 2022.

The event was structured by a wheel of fortune that at each (palliative) turn selected one member of A𝘱T to take to the stage with a 5–10-minute act, presentation, or performance.

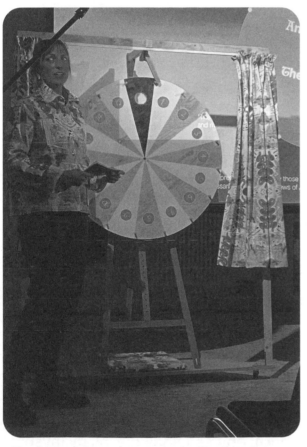

Kasia Fudakowski presents *An Evening on the Palliative Turn* at KW's pogo bar, photo: Ethan Hayes-Chute

After the initial introduction, which included an exercise from the Last Aid course and the audience reading through the A𝘱T manifesto aloud, everyone was asked to set a timer on their phone for 57 minutes*, the alarms would signal the end of the event. It was made clear there were more acts than available minutes. Loss was guaranteed.

Two numbers on the wheel added uncertainty and jeopardy to the event. Number 15 was 'Stand in Stand Out' in which an audience member would be invited to volunteer to permanently leave in order for the event to continue, and number 16 was 'Sudden Death', which if selected would end the event instantly.

With a focus on the cosmically comic side of saying goodbye forever, *An Evening On The Palliative Turn* proposed a mix of comedic monologues, costumes from curtains, cartoons, songs, empathy, improvised theatre, tombstones, generosity, films, live music, laughter, and removals, as well as a guaranteed end—followed by standard sad fare of G&Ts and cucumber sandwiches.

Participating A𝘱T members; Simon Blanck, Annemarie Goldschmidt, Ethan Hayes-Chute, Karin Kytökangas, Mathias Lempart, Dafna Maimon, Kevin Napier, Leila Peacock, Rattelschneck, John-Luke Roberts, Xavier Robles de Medina, Lydia Röder, Anna Szaflarski, Nala Tessloff, Marcus Weimer, and Olav Westphalen all prepared a wide variety of palliatively themed acts. While 'Stand in Stand Out' was selected by the wheel, number 16 'Sudden Death' was not, and the event ended when a soft symphony of individual alarms went off around the 57 minute mark, cutting off Ethan Hayes-Chute's 'Pläsnt Dschörnie' performance. Leila Peacock, Rattelschneck, Kevin Napier and Anna M. Szaflarski were also sadly not selected by the wheel.

The event could not have been possible without the help and support of Sofie Krogh Christensen, Linda Franken, Nienke Roth, Harry Haddon, Paolo Combes and the recurring generosity of A𝘱T members.

*On the night, Fudakowski forgot to do this, remembering only halfway through the first act, so the audience was in fact asked to set their alarms for 53 minutes, which led to some confusion and a mild disparity in timing when the time did come.

John-Luke Roberts performs *It is (A Bit) Better at An Evening on The Palliative Turn*, KW Berlin, 2022, photo: Nienke Roth

REPORT
An Audience Perspective on *An Evening on the Palliative Turn*
Niki Katsara

I'm asked to laugh. I'm forced to laugh. I'm laughing. I'm observing myself laugh. There I am laughing. I like laughing. I choose to laugh. All I wanna do is laugh. I don't wanna stop laughing. I'm asked to stop laughing. I'm forced to stop laughing.

With *Laughter Yoga* presented by Xavier Robles de Medina I can describe the paradox of the involuntary / voluntary nature of life and death. We are asked to be born. We choose to live. We love living. And then we are forced to die. And all in between. A prolonged (voluntary) nerve exercise. And what remains? 'A Bummer'. A reflection of us through a variety of stones and fonts.

I'm spending all my life choosing life. Making sure the choices 1 to 15 are the ones true to myself at any time given. Spending all my day learning about the miracle of life through the lens of a medical student. And all I know is brain death is defined as 'irreversible and unresponsive coma, absence of brain stem reflexes, and apnea'.

I go back to my old Greek ancestors to seek comfort. Aristotle's death is to return to one's real home. Then maybe I want to stay abroad. Socrates' death is a good thing if you are a moral person. Then maybe I'll be immoral. To be immortal.

And so I find myself alone, as I was born, and as I shall die, all by myself, among other people with beating hearts and sparkling eyes, looking at Kasia acing that pancreatic cancer jacket and fearing once again with the same agony and the same nostalgia something that has not even come yet: 'Number 16: Sudden death'.

I'm walking back home. And I ask myself maybe the only question worth asking: So Nicky, most importantly, how would you like to go?

as Tony packed his Isotoner gloves and his Garfield giclee prints into the box his father had set out for him the night before. He looked back again at the space he once called his bedroom and found it hard to imagine ever finding the same level of comfort and ease in another house, in another town, and, who knows, maybe another county.

He closed the door and made his way downstairs where he saw his uncle Moke helping Suzanne put her dishes between sheets of free local circulars that Tony had collected from the supermarket. Moke had a way with fine porcelain, and Suzanne knew her cherished heirlooms were safe, at least until they made their way out to the moving truck. From there on, it was just too dark a thought to wonder what might happen to them as the truck clipped the curb on the way out of the driveway. She shuddered and turned to Tony, asking him if he'd put all his chargables in a clearly-marked tubby so they could be found easily. This reminded Tony of the cashier at the supermarket who would always ask if the gum should be 'left out' to allow for an easy chew in the car on the way home. Amidst such low-quality memories, a voice pushed through his mental fog and connected with Tony's brain:

"Dear, did you find everything in your closet?"

It was Father. He was cleaning his glasses with the waist of his tight and tattered sweater. He looked tired, and sad. Tony recalled a quip that old apartment buildings in New York City are all just dust held together with one hundred layers paint, and that that's what his dad looked like; it was the veneer of adulthood that kept him together.

Tony replied, "Yeah, thanks, Fa, I got all my stuff out my my-my stash, thanks." He recalled the tiny shoes and cereal toys he had pulled out of the old furnace register earlier in the day with a fondness most delicate.

Tony had decided to leave his animal-and-nature magazines for a future generation, despite the fact that he knew in his heart that this old apartment, where he has lived his whole life, would be gutted and turned into some sort of clashy pied-à-terre for some landlord's kid from another state. This made him mad, so he punched the old mattress he used to sleep on; it groaned slightly and he left the room, overlooking the compressed areas of carpet left behind by the furniture that they had already brought out to the front of the building.

Downstairs, Uncle Moke, Suzanne, Father, and a man Tony had never seen before were watching something out the window of the kitchen.

"Unc–?"

"Sshh, hold on a sec– there's a... oh, never mind– it's gone. What's up, kiddo?"

Tony had lost his train of thought. "Oh, um, nevermind, I don't think I know."

Uncle Moke put down his paper coffee cup on top of the counter and turned to Tony, "Hey, I know this is tough. Ever since your mom gave up the lease here, it's been a world of confusion for us all."

"Yeah," sniffed Tony, "You're right. I just wish that we didn't need to focus on this sort of stuff all the sudden. Sharon needs my help with a project for her grandfather's funeral."

Suzanne clapped Tony on his shoulder and left the room. She had been crying, he thought, but wasn't sure for how long. Suzanne didn't usually cry, not even when they watched *The Notebook* last weekend, and everyone else had cried at multiple points in the movie, even Tony's buddy, Bonod, who forbade Tony from even *thinking* about him crying while watching *The Notebook*. Tony didn't think he'd find out just this once, and enjoyed the memory. With a definitive blink, Tony decided it was time to take a break and go outside to look at their stuff. He left his dad staring out the kitchen window.

As Tony headed outside, he caught a glimpse of his own reflection in the streaked, hand-print-covered glass

The art of the Palliative Turn

follows the principles of palliative care and medicine:

It acknowledges the existence of the end, and plans for it.

It affirms life and regards dying as a normal and necessary process.

It intends to neither hasten nor postpone the end.

It mitigates suffering, gives pleasure, generates joy wherever possible.

It accompanies a dying person, culture or belief system on their final stretch and shares the horrors of darkness with them.

But

it also shares intensity, beauty and excitement, the acute awareness of life which accompanies death.

| | | | | | | |
|---|---|---|---|---|---|---|
| It | is | empathetic | and | communicative. |
| It | is | collaborative | and | non-hierarchical. |
| It | is | multi-disciplinary | and | multi-perspectival. |
| It | acts | and | speaks | in | good | faith. |

The Art of the Palliative Turn asks:

how would you like to go?

Become an active part of the Palliative Turn

www.palliativeturn.org info@palliativeturn.org

For immediate release: **A call for the Palliative Turn**

| This | culture | is | coming | to | an | end. |
|---|---|---|---|---|---|---|
| This | society | is | coming | to | an | end. |
| This | economy | is | coming | to | an | end. |
| Your | body | is | coming | to | an | end. |

They will either transform beyond recognition or perish.

Business as usual has nothing to offer anymore.

Ask yourself: What are the real-world effects of your work and actions?
Are you just trying to appear virtuous?
Do you want to be on the right side of history?
Are you trying to carve a living out of your criticality?

That, too, is Business as usual. It must come to an end.

...instead the end of everything as we...

BE PRESENT AND FREE FROM STRESS

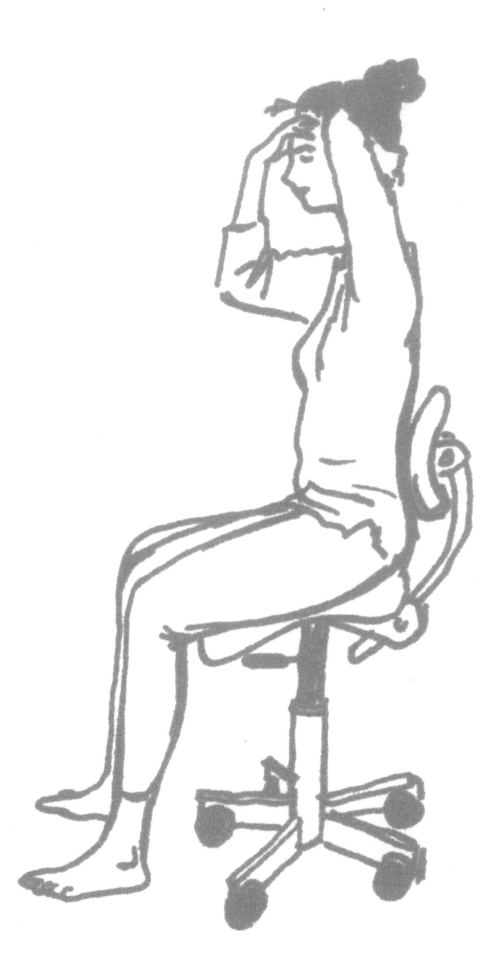

Annemarie Goldschmidt

Important note! You can do this exercise whenever you want to. You can do it on your own or let another person hold your head with a very light touch while you go through the procedure.

Exercise: Be Present And Free From Stress
Annemarie Goldschmidt

To be fully present. To let go of stress reactions and worries. To be ready to get started. The purpose of this exercise is to assist the brain and body in letting go of negative emotional stress, and to be present in the now.

Information: When stress/distress hits the body and brain, it prevents us from thinking clearly and learning. When we are stressed and when we worry, it is difficult for the many different parts of the brain to work together. Holding the forehead and the back of the skull with a very light touch brings blood circulation to these areas. When using the power of thinking, we can visualise how the stress reactions leave the brain and the body, and enhance the energy flow.

What to do and how:

①

Sit in an upright position or stand up, making sure you are well balanced on your feet.

②

Using a very light touch, cover your forehead with one hand and the back of your head with the other. It doesn't matter which hands you use.

③

Breathe calmly.

④

Let any unpleasant or worrying situation be 'history'. Use your power of thinking to let go of any tension in your body and brain.

⑤

Replace the stressing or worrying situation with a feeling of being OK. Using positive thinking will bring healing to your cells.

⑥

When you are feeling OK in the present time, right now, take a deep breath, move your hands away and breathe out.

⑦

Sit for some minutes and bring your awareness to how you let go of some or all the tension in your body and brain. You will feel an increased flow of energy and a raised awareness.

Now start working, reading, or whatever is the next part of your day.

Last Night I Dreamt I Was A Shoe
Teal Griffin

To comprehend is to grasp the nature, significance or meaning of a thing. But some things, by the very nature of their scale, seem wholly incomprehensible. Scale feels relevant. Scale in relation to relative and proportional size; to climbing; to a musical arrangement in ascending or descending order of pitch; to weight and balance; dry skin flakes that fall from a scalp or the scales that form on the bottom of a kettle. I keep thinking about trying to grasp the sea in your hands, or the iceberg seen from the surface, of which its true size is hidden from view.

Recently I've been taking these walks through Nunhead and Camberwell cemeteries, strangely drawn to the dead, at a time when talk of death seems ever-present. I find myself spending more time reading the headstones—something about rows of strangers lying next to each other whilst the living maintain the mandatory two metres. Strips of blue sky, gaps between the tree tops above remind me of something I read about 'crown shyness' in which the crowns of some species of trees keep their distance from each other and so form attractive patterns of channel-like gaps in the canopy. Occasionally you might come across a hastily filled grave, the earth dumped in big clay lumps—most probably a funeral since the pandemic. Unfinished. TBC. Words on hold or perhaps forever unsaid?

From the inside of a street-facing window, in the sort of place where one might now expect a rainbow are the words 'LOST PEOPLE ARE HAPPY IN THE UNDERWORLD' inscribed in orange crayon beneath the outline of a patchily filled-in heart.

I walked my old dog Zen around Nunhead Cemetery for 16 years, which is almost 100 in dog—up until last November when he died. Abandoned after the war, the cemetery became so overgrown that when I was a kid I used to wonder why anyone would build a cemetery in a forest? Thick trees now emerge out of graves with tomb-splitting roots. So many buried bodies, so much fertiliser for young trees. Literally *life emerging from death*.

When a whale dies in the ocean, its carcass will initially float on the surface, providing sustenance to hungry scavengers. As its mass decreases, eventually it will sink to the bottom. Once the body comes to rest, the leviathan cadaver can become home to entirely new ecosystems. Biologists refer to this as a *whale fall*.

When we die we leak water. The skin tightens, and goes sallow and yellow as the blood that gives us colour stops moving. As bodily functions cease, the muscles that keep the bladder and sphincter in control, release.

As you die you become lighter. Often when people are close to death their bodies become more porous, lose weight, sort of become transparent, ghosts of themselves before they're ghosts. We often think about death in relation to the earth, burying (in the West, at least), cremation reduces the body into light fluffy ashes, which then blow in the wind. The body's decomposition in relation to gravity. And how ash can be dissolved in water. Or inhaled. Or swallowed.

As I help the upside-down grasshopper off its back and watch it hop away, I wonder about the Victorian dust heaps that were once the size of hills. One by King's Cross was supposedly so large that cart-horses transporting dust to its precipice looked more like ants when glanced from a distance. Ash collected from households was used as filler in the making of clay bricks, which built new homes. Ash to fuel a fire—*The march of bricks and mortar,* whole neighbourhoods appearing as if overnight. Maybe these dust heaps were some kind of early progenitor of our recycling centres: homes made from home waste; *the solidity of a cityscape emerging out of the ephemerality of ash, and dust.* Maybe the heaps looked like grey icebergs—to anyone who'd seen an iceberg before.

<div style="text-align:center">

The weight of a
Dust heap
A dance of scales

</div>

Last Christmas I brought back some seeds from the country of my mother's birth. It was my first visit in ten years. The land was stricken and burning, the city air thick with the smell of bushfire, the sea dark with ash. Smoke plumes so large they created their own thunderstorms. Orange skies. Metal-melting-earth. On a walk in the park with my uncle I stopped to photograph the dry, cracked clay-beds of what were supposed to be the lakes I remember seeing as a child. Looking up into the haze, he muttered that he'd never seen Sydney skies like these before. He's lived there for more than 70 years. I bought the seeds in sealed foil packets from a tourist shop at the airport on the way home.

Ten weeks ago I sowed the seeds into three-inch-deep trays, careful not to accidentally blow them away with my breath as I scattered them into the earth, and covered the tray loosely with clingfilm. Seedlings first started to appear two weeks later—a tentative green. The first couple to emerge turned out to be weeds that had presumably lain dormant in the potting mix. I left them to grow too. I read somewhere that the small and weak should be plucked out to encourage the strong to prosper. On the TV three old white men stand at podiums announcing something about herd immunity and saving 'the economy'. *The economy for whom?* Two weeks after the first emergence I repotted every seedling into larger trays, the small and large, the slow and the vigorous, the invited and the unannounced, the sick and the healthy.

I suspended a fluorescent light-bulb so it sat just above the plants. Wiped down a fungus that spread and nursed the infected plants. Checked the dryness of the soil twice a day, and watered from the bottom up. Not wet, not dry—always moist. Repotted tiny stems with tweezers using toothpicks as aides. Moved trays outside in the morning sun, and back in again at night. Guarded from snails and caterpillars. Fed them once a week.

Gradually, at first tentatively, yet now enthusiastically, they responded.

Almost a hundred baby trees, from eight varieties of Eucalyptus, not much bigger than match-sticks: tiny life. It feels somewhat absurd or affirming or something, to nurture new life small enough to fit into a teacup, in the knowledge that one day, with enough care it can grow to be larger than a house.

In 2013, a great storm washed back the sands of a Norfolk beach to reveal a set of human footprints. They were the oldest known of their kind yet discovered outside of Africa; possibly more than 800,000 years old. A professor from the Natural History Museum likened the discovery to 'a needle in a haystack'. The varying sizes suggested that they were made by a small family group walking up the beach, presumably having made their way over to Norfolk via a strip of land that once connected Britain to continental Europe a million years ago. It is believed that they were members of the proposed archaic human species *Homo Antecessor*, which has long since vanished. Two weeks later, the footprints were swallowed back up by the sea.

Sun-set = sun-rise.

Indigo arrived in my life six months after Zen had left. She lies at my feet asleep as I write this. On her first night I put her in Zen's old bed and gave her his favourite blanket and watched as she sniffed and took in his scent. Whilst they can never meet physically —I like to think that maybe through his scent, Zen can pass something over to Indigo, maybe a small reassurance and some of the wisdom that he gained over the years, a sort of spiritual-scent-handshake-embrace, that whilst one story may end, it might inspire the next, as it emerges and grows into view.

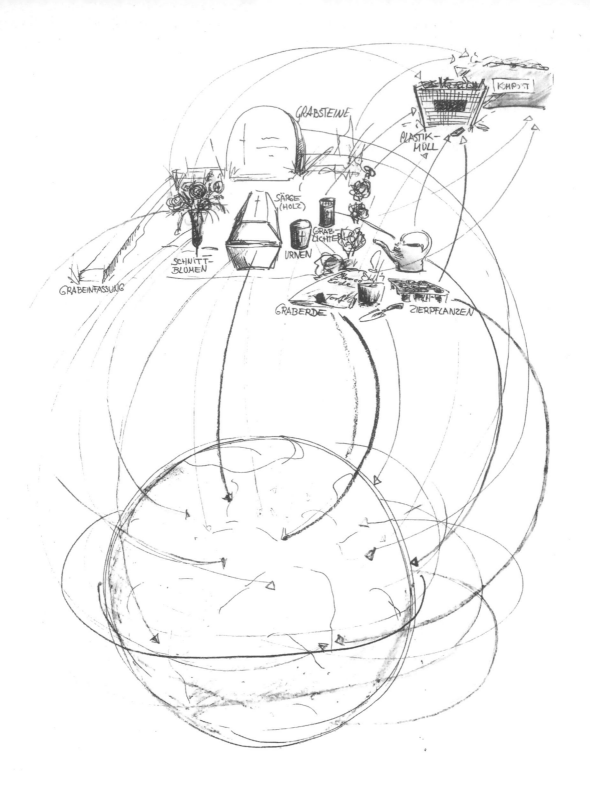

CAN YOU ALSO IMAGINE A CEMETERY
AS AN ECOSYSTEM (PLANTS, INSECTS,
BIRDS, SMALL MAMMALS, ...)?

CAN CEMETERIES HELP TO
INCREASE BIODIVERSITY?

DO CEMETERIES HAVE ANY
IMPACT ON THE QUALITY OF
LIFE (IN CITIES)?

Jana Thiel: *Soil and Green*, 2021, Excerpt from artist publication

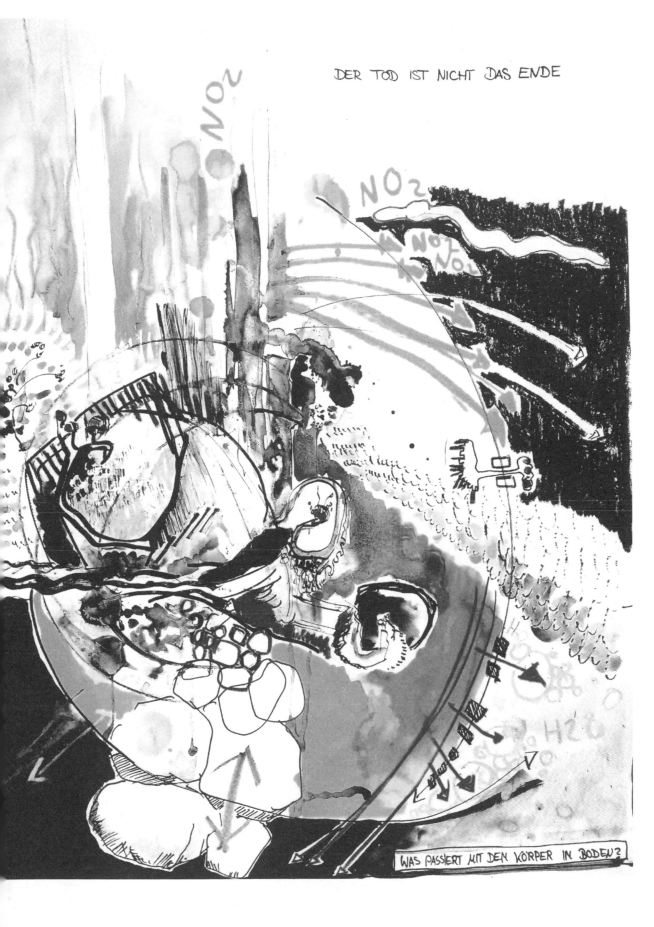

Karin Kytökangas, *At least we tried*, 2021, sticker design, please cut out and use your own glue to apply.

Preparing for the Palliative Turn
Lars-Erik Hjertström Lappalainen

Around 2009, when contemporary art conclusively became an object of theoretical investigation, possibly because it was nearing its end, Boris Groys described its contemporaneity in a striking fashion: 'The present has ceased to be a point of transition from the past to the future [...] Today, we are stuck in the present as it reproduces itself without leading to any future.'[1] The contemporary quite simply differs from other eras through lack of temporal movement. Time was conceived as a synthesis between a past, present and future, while the contemporary simply didn't connect past or future with the present. The contemporary now merely revolves around itself in a desire to become materialised as contemporaneous. This is what Fukoyama's *End of History* implies: the contemporary does not advance, it simply spins out in broadening circles, revolving around itself it spreads towards the end point, a liberal market economical democracy which covers the rest of the planet. Globalisation is a spatialisation of the contemporary's movement towards significant immutability.

This forms a difference between contemporary art and modernism, which wanted to move forward, towards a society and culture to come. It could help society progress, improve the situation. Contemporary art can't do this, because its function is already from the outset palliative; to help people relate to the end point, namely the contemporary.

On a larger scale, it helps by spreading the political system, mainly in the form of biennials and fairs, continuously reduced to their core, capitalism. But its definite, palliative task is fulfilled every time art demonstrates that it has the same driving forces as the rest of society, namely of and for freedom. Freedom emerges through the description of the contemporaneous as disconnected from both past and present. Which is why, according to Groys, contemporary art is obsessed with rewriting history.

The point has been that history can be rewritten in an infinite number of ways since the contemporary isn't conditioned by time. History illuminates our time, without dictating the conditions of our freedom. History only exists as representation, not as fact. And the same undeniably goes for things that exist within the contemporary: individuals, politics claim, but only those who can be represented in the form of interest groups within the system. Freedom lies in representation not representing what it actually is. Neither does the future define the content of the contemporary as it lacks a telos. So, we must prepare ourselves for all kinds of futures—which, nevertheless, only are thinkable within the contemporary as long as they do not differ from its fundamental principle, that is to say economic growth. (The economy does not let us predict the 'future'— thus nothing can change. Economy provides no new conditions, as content is so vague, it essentially offers pretexts for action.) Considering that contemporary thought has

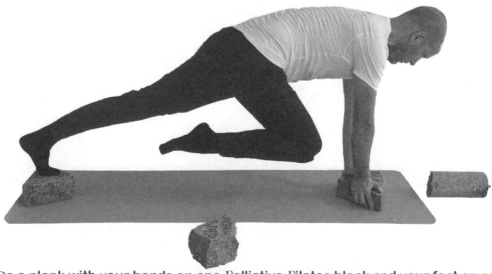

Do a plank with your hands on one Palliative Pilates block and your feet on another. Lift your right leg toward your right elbow. Then lift your left leg toward your left elbow. Repeat fifteen times.

become thoroughly economised one might say that the art world is 'a kind of experimental ground for the hammering-out of a certain ideal of freedom appropriate to the current rule of finance capital'. [2] Art cannot do much more than operate palliatively, making life without time a little more comfortable.

A climate catastrophe is difficult to contemplate in a contemporary manner as it provides an image of the future that differs from the contemporary, and because it must be thought as representing an actual reality within the contemporary. How would this present, which only comprises 'unproductive, wasted time', as Groys declares, produce its own damnation? From freedom? Absurd. The contemporary is its own bubble. Our mentality is that of the motorist, driving in the cockpit, where impressions, conversations and music don't come from outside and the miles drearily pass by. Outside, time passes, but not inside the car. The so-called Krautrock music, inspired by the highway, anticipated what would become the contemporary condition. And Starman, Elon Musk's car-satellite in space, is a perfect interpretation of contemporary thinking. Now every car that passes represents the monad of 'the contemporary', which without windows reflects everything past and future, without being limited by it.

And if, in this situation, we claim a 'palliative turn in art', one must adhere to certain nuances. We must at least leave the individual and the private behind and replace them with some kind of universals. It is what art does, not what artists do, that should change or be reconsidered.

It is not a number of people dying, but humankind or the anonymous within us, that is, something that is neither fact nor representation, but an outstanding cultural creation. The palliative turn must be a turn to processing the loss of the universal anonymity and of art as its expression. That processing could still be part of anonymity and art, a last time but this time forever.

1 Boris Groys, 'Comrades of Time', *e-flux journal* #11, December 2009, https://www.e-flux.com/journal/11/61345/comrades-of-time/

2 Nika Dubrovsky and David Graeber's description of the art world. See their text 'Another Art World, Part 1: Art Communism and Artificial Scarcity', *e-flux journal* #102 https://www.e-flux.com/jour- nal/102/284624/another-art-world-part-1-art-communism-and- artificial-scarcity/ [accessed 3 February 2021].

Marcus Weimer in a meeting with Olav Westphalen, April 2020. Weimer is taking the Zoom call in a coffin which he built during a workshop arranged by the German Association for Palliative Medicine (DPG) to prepare the cartoonists Weimer and Westphalen for their task to develop a humour concept for a convention of palliative medicine in Wiesbaden later that year. The Build Your Own Coffin workshop was held by artist Anna Adam and palliative care professional Lydia Roeder, who later became one of the earliest members of APG.

Life precedes Death – Death ends Life
Annemarie Goldschmidt

Our conscious mind *knows* this, but doesn't experience it until it happens. However, I am sure the body-mind experiences the physical, emotional, and spiritual feeling of the dying process every millisecond. Life is the precondition of death. The everyday dying of old cells is the precondition of creating space for the birth of new cells. Without life, death wouldn't exist. Without death, life couldn't be. It is about polarity, about two sides of the same coin.

And it is about a Cycle, a Life Cycle.

Let's take a look at the old Chinese philosophy, the Chinese way of experiencing life. Chinese philosophy tells us about five elements:
Wood, representing spring and birth
Fire, representing summer and ascending energy
Earth, representing late summer and ripening adult energy
Metal, representing autumn/fall and the declining energy phase
Water, representing winter, death, and from there rebirth.

In this philosophy they/we view the macrocosmos, the outside world, as equivalent to the microcosmos, the world of our cells. As everything exists and moves in a specific rhythm in nature, everything exists and moves in a specific rhythm inside the human body, inside every tiny cell. Whether we talk about plants, human beings or other kinds of life, the same procedure occurs: we start with the seed, or the sperm and the ovum, the beginning of life, spring/wood. The seed grows and develops through spring into summer/fire, the foetus grows through childhood into young age. The plant as well as the human being continues to grow in the warm sun, and both develop further into late summer/earth. Both now start to be fruitful, each in their specific way. Where trees bear fruits, human beings develop physical skills, thoughts, knowledge, and ideas, and now in this season they are ready to be picked and used. In autumn/metal we draw back our energy. The trees from leaves to branches, to the stem and into the roots. No longer needing photosynthesis, they go to its own centre. Human beings most often do the same: go to their centre, realising the cycle is moving, the energy declining.

We have now moved through the elements, the seasons, the different stages of life, and we have reached the winter/water element, the end of every cycle, which means the end of life as it is. After this end of cell life, which we call death, a new cycle will begin. Every cell has this knowledge built into its genome, passing it on to every next cell, like a relay runner handing the baton before stopping. So why not hand over the best possible message by taking care of our cells through their lives, our life? Maybe we could expand the name and purpose of our project
'A palliative turn in art'
to …
'The art of turning palliation into our lives at any and all parts of our life cycle'
I imagine all our cells 'clapping their hands' when we do!

Remember: palliation derives from the word 'pallium', which means 'cloak' or 'blanket'. Something which makes you feel warm, protected, and comforted.

REPORT
The First Palliative Audit
by APC

For APC's exhibition in Bremen, Kasia Fudakowski created an assessment form with questions (see page ⑳) derived from approaches to palliative care, and together with Dafna Maimon and Olav Westphalen carried out an audit asking: How palliative is the Künstlerhaus Bremen? They interviewed nine internal members of the Künstlerhaus Bremen from the directorial, curatorial and maintenance team, artists and other tenants of the building, as well as two external representatives from neighbouring institutions. The APC team also completed their own questionnaires. In the context of assessing an institution, answering these questions required both a simple, practical and observational, but also an abstract, existential and philosophical approach.

The results of the audit (shared opposite) were presented during the opening of the exhibition at Künstlerhaus Bremen. The institution ended up with an overall score of 50.1 corresponding to a 'Quite Palliative' rating. Suggestions were made by the APC team for how the Künstlerhaus Bremen might become more palliative. These included putting up 'How to foster a healthier relationship with death' posters by John-Luke Roberts and Fudakowski in every toilet, introducing a 'swap around' day where roles within the institution are exchanged within the team to shake up the hierarchy, and finally, renaming the institution as 'Gummihaus Bremen'. This final suggestion was backed up with suggested branding as well as a short presentation on the palliative qualities of rubber as a material. It was almost universally agreed by the audit participants that Künstlerhaus Bremen needs to be more courageous in general, but specifically in renaming their long contested name. Whether any of these suggestions have been implemented will be assessed at the closing of the exhibition.

Patricipants: Dafna Maimon, Olav Westphalen, Kasia Fudakowski at Künstlerhaus Bremen in 2022, all photos: Kasia Fudakowski

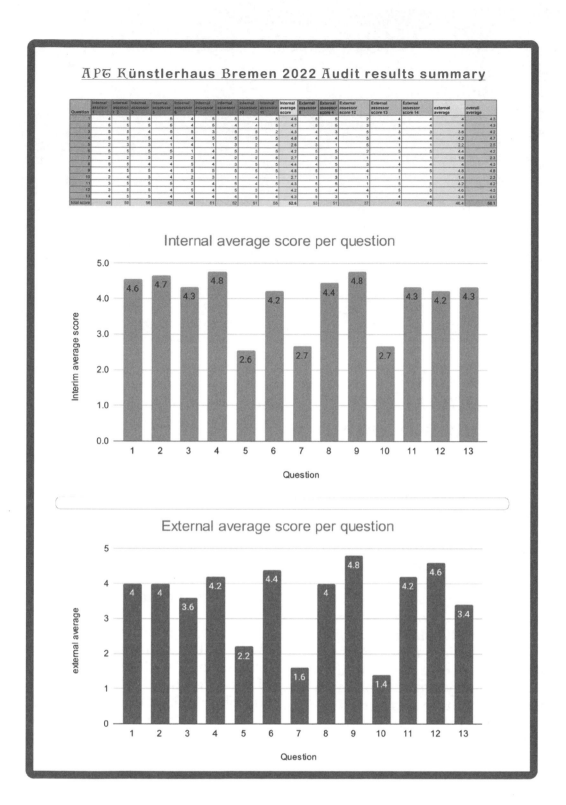

APT Künstlerhaus Bremen 2022 Audit results summary

| Question | Internal assessor 5 | Internal assessor 3 | Internal assessor 3 | Internal assessor 5 | Internal assessor 6 | Internal assessor 7 | Internal assessor 8 | Internal assessor 10 | Internal assessor 11 | Internal average score | External assessor 8 | External assessor score 4 | External assessor score 12 | External assessor score 13 | External assessor score 14 | external average | overall average |
|---|---|---|---|---|---|---|---|---|---|---|---|---|---|---|---|---|---|
| 1 | 4 | 5 | 4 | 5 | 4 | 5 | 5 | 4 | 5 | 4.6 | 5 | 5 | 2 | 3 | 4 | 4 | 4.3 |
| 2 | 5 | 5 | 5 | 5 | 4 | 5 | 4 | 4 | 5 | 4.7 | 5 | 6 | 3 | 3 | 4 | 4 | 4.3 |
| 3 | 5 | 5 | 4 | 5 | 3 | 5 | 5 | 2 | 4 | 4.3 | 4 | 3 | 5 | 3 | 3 | 3.6 | 4.2 |
| 4 | 5 | 5 | 5 | 4 | 4 | 5 | 5 | 5 | 5 | 4.8 | 4 | 4 | 5 | 4 | 4 | 4.2 | 4.7 |
| 5 | 2 | 3 | 3 | 1 | 4 | 1 | 3 | 2 | 4 | 2.6 | 3 | 1 | 1 | 1 | 1 | 2.2 | 2.5 |
| 6 | 5 | 5 | 5 | 5 | 1 | 4 | 5 | 3 | 5 | 4.2 | 5 | 5 | 2 | 5 | 5 | 4.4 | 4.2 |
| 7 | 2 | 5 | 3 | 2 | 2 | 4 | 2 | 2 | 5 | 2.7 | 2 | 3 | 1 | 1 | 1 | 1.6 | 2.3 |
| 8 | 5 | 5 | 4 | 4 | 3 | 4 | 3 | 5 | 5 | 4.4 | 4 | 5 | 3 | 4 | 4 | 4 | 4.3 |
| 9 | 4 | 5 | 5 | 4 | 5 | 5 | 5 | 5 | 5 | 4.8 | 4 | 5 | 4 | 5 | 5 | 4.8 | 4.8 |
| 10 | 2 | 4 | 3 | 4 | 2 | 3 | 1 | 4 | 1 | 2.7 | 1 | 3 | 1 | 1 | 1 | 1.4 | 2.3 |
| 11 | 3 | 5 | 5 | 5 | 3 | 4 | 5 | 4 | 5 | 4.3 | 5 | 5 | 1 | 5 | 5 | 4.2 | 4.2 |
| 12 | 3 | 5 | 5 | 4 | 5 | 4 | 5 | 3 | 4 | 4.2 | 5 | 4 | 4 | 5 | 5 | 4.6 | 4.3 |
| 13 | 4 | 5 | 5 | 4 | 4 | 4 | 4 | 5 | 4 | 4.3 | 5 | 3 | 1 | 4 | 4 | 3.4 | 4.0 |
| total score | 49 | 59 | 56 | 52 | 48 | 61 | 52 | 61 | 55 | 52.6 | 53 | 51 | 37 | 45 | 46 | 46.4 | 50.1 |

Internal average score per question

| Question | 1 | 2 | 3 | 4 | 5 | 6 | 7 | 8 | 9 | 10 | 11 | 12 | 13 |
|---|---|---|---|---|---|---|---|---|---|---|---|---|---|
| Interim average score | 4.6 | 4.7 | 4.3 | 4.8 | 2.6 | 4.2 | 2.7 | 4.4 | 4.8 | 2.7 | 4.3 | 4.2 | 4.3 |

External average score per question

| Question | 1 | 2 | 3 | 4 | 5 | 6 | 7 | 8 | 9 | 10 | 11 | 12 | 13 |
|---|---|---|---|---|---|---|---|---|---|---|---|---|---|
| external average | 4 | 4 | 3.6 | 4.2 | 2.2 | 4.4 | 1.6 | 4 | 4.8 | 1.4 | 4.2 | 4.6 | 3.4 |

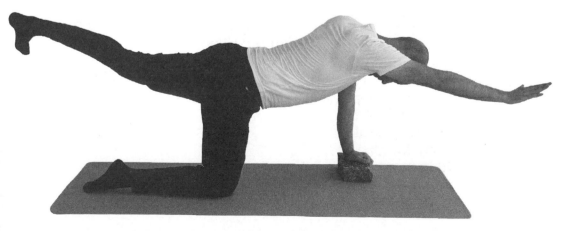

Stand on all fours with your hands resting on a Palliative Pilates block. Raise your right hand and left leg and stretch them out as far as you can, then do the same with your left hand and right leg. Repeat twenty times.

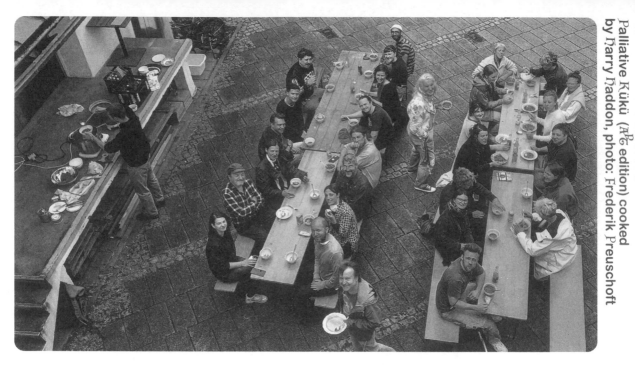

Palliative KüKü (APT edition) cooked by Harry Haddon, photo: Frederik Preuschoft

REPORT
The Palliative Turn at Künstlerhaus Bremen
Teal Griffin

The Association of the Palliative Turn came together in Bremen for a group exhibition and series of events, hosted by the Künstlerhaus Bremen as part of its 30th anniversary.

Stage One—Creating a plan:
Curated by Nadja Quante, in close collaboration with Kasia Fudakowski and Olav Westphalen, *The Palliative Turn* took the form of a collaborative and interdisciplinary project spanning across an exhibition and series of events over months bringing together over 30 contributions from different practices.

Managing any symptoms:
The Bremen conference kicked off with its first event: a special APT edition of the weekly KüKü (a communal lunch in the courtyard for the Künstlerhaus team and the artists and members from the studios). Harry Haddon's generous culinary skills delivered a tomato soup of depth and flavour to match the warmth of the Künstlerhaus welcome. The meal provided an opportunity for APT members new and old to meet or reacquaint, as well as an introduction to the Künstlerhaus community.

Offering emotional, spiritual and psychological support:
The opening night included speeches by Nadja Qante, a demonstration of *Palliative Assessment* by Kasia Fudakowski, Dafna Maimon and Olav Westphalen (assisted by Mika), and a melodic performance of the APT *Manifesto* by Maxwell Stephens.

The exhibition itself was made up of 21 artworks, delivered by 19 different artists and collaborators.

There were some new faces:
As ever, the APT network continues to expand, with recent recruits Laura Pientka, Ruth Rubers and Jana Thiel—all graduates or students of the University of the Arts Bremen—bringing some local flavour to the conference. Indeed, Thiel served up a veritable buffet in collaboration with Volker Grahmann in their *THANATOLOGIE MEDITERRANEUM—Studies on the palliative Tischleindeckdich*, 2022, shown alongside Pientka's *Tender Blossom* (2022), a male anus candlestick holder, and the sound punctuations of Rubers' *You Never Know*.

Teal Griffin, *a mobile for Arya*, 2021, photo: Fred Dott

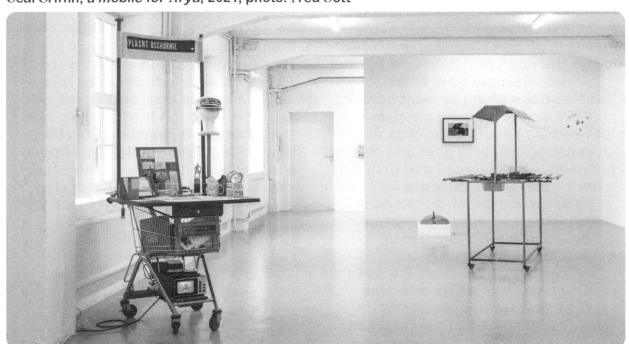

The Palliative Turn, exhibition view, Künstlerhaus Bremen, 2022, photo: Fred Dott

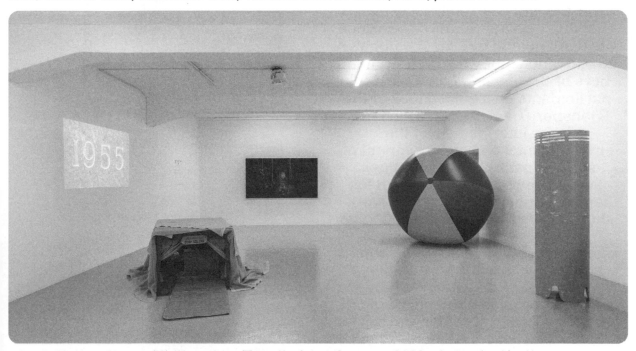

The Palliative Turn, exhibition view, Künstlerhaus Bremen, 2022, photo: Fred Dott

Consider if you want to be resuscitated:
The affective material coldness of Thiel's steel sculpture and the enlarged grave head-stone surfaces of Simon Blanck's projected 1900–1999 were complimented by the warm, embracing cubby hole of Dafna Maimon and Ethan Hayes-Chute's *Camp Solong*: *Sheltered Hangups*, a new collaborative work that addresses saying goodbye. A variety of material and scale played out across the exhibition, from wax to ceramic to human teeth, from tiny plastic carrier bags to a giant inflatable beach ball.

The exhibition extended beyond the exhibition space:
Upon arrival, visitors were greeted by the striking black and yellow posters of Alex Kwartler, plastered across the courtyard entrance. Further into the courtyard of the Künstlerhaus, along its plant borders, were scattered the nameplates of Mathias Lempart's *Riddle*, made in collaboration with grief and death counsellor Lydia Röder and reshown here from its first outing at 2021's palliative exhibition in Potsdam, forming a palliative-word-game-breadcrump-trail leading up to the gallery's entrance. Up the stairs and across the walls reverberated an excerpt from the *Manifesto* (mural) designed by Mathias Lempart and Sascia Reibel.

Offering practical support:
Over the first weekend following the opening, a palliative drawing session was held, guided by Olav Westphalen, an exhibition tour was given by members of the APT, and Jana Thiel took participants on a guided tour of the Riensberg Cemetery, in which they were informed about the environmental and ethical impact of some Western burial practices. Further public events planned for September include a *Last Aid* workshop with Lydia Röder, a *Health and Cell Death* workshop with kinesiologist Annemarie Goldschmidt together with artist Per Hüttner, a workshop *No Kids* with the artist and comedian Louise Ashcroft, in which we are invited to consider and reflect upon what it means to forsake our genetic legacy and not have children, and finally a palliative dinner.

Saying goodbye:
At the end of the opening weekend, APT and Künstlerhaus team members converged again for a sit-down meal—this time provided by the soon-to-close 'Kuss Rosa'. This was a truly palliative meal—in the context of a closing business—and in which members chose options from a limited menu, depending on what was or wasn't available, and chose what they wanted to pay on exit. Sadly, Kuss Rosa has since closed—hopefully the APT's visit lent some assuring energy toward the eventual end.

Giving you a good quality of life:
The Association of the Palliative Turn will reunite for the finissage of the Bremen edition at the End of September and from which this publication, its first, or last, will be delivered. Through these pages, new collaborations resulting from the Bremen happening will grow, appear and manifest themselves, the latest iteration and continuation of the APT's ever evolving form of meeting, discussion, experimentation and collaboration.

Maxwell Stephens, Performance of APT *Manifesto*, Künstlerhaus Bremen, 08.07.2022
Photo: Kerstin Rolfes

Email Call For Male Models
Laura Pientka

Give me your anus (please)

Pientka, Laura Sofie ◄ ██████████████████████

Mi 22.06.2022 18:25

An: ALLE Studierende █████████████████████ Westphalen, Olav ██████████████

Dear all,

I am (quiet urgently) looking for someone who can put a candle (2,4cm diameter) in his anus. I need a male Model and you have to lie still for at least 20 minutes because I'm going to make a plaster mold out of it.

tHe BiGgeR tHe BetTer

Love to hear from you! (exhibition takes place on 8th July at Künstlerhaus)

We can negotiate a salary (if a nice gift for your parents next Christmas isn't enough).

xxx
Laura

CAMP SOLONG

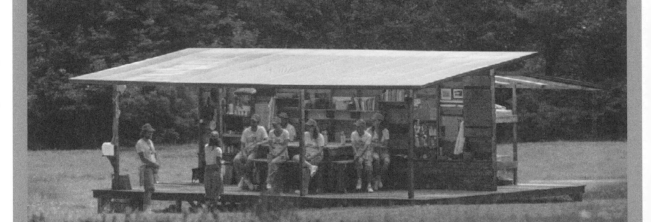

GOODBYE is for EVERYONE

An Outside Perspective on the Audit in Bremen
Rose Sanyang-Hill

The term 'palliative' derives from the Latin word *pallium*–which means to coat or to cover. The measures in palliative medicine have the goal to reduce pain in the event of incurable disease.

When I was asked by A^PC member Kasia to participate in a survey regarding the *Palliative Turn* at the Künstlerhaus Bremen, deep thoughts popped up in my mind.

Are the A^PC workers midwives, I asked myself?
Do they help us transition into another state of consciousness?
The work of the A^PC is for me a subtle push in the right direction. A search for life's purpose. How do we get to the essence? Where does our humour come in? How to change dimensions? Do I appreciate the constant transformation?

I deeply honour the inspiration and the effort of the A^PC crew.
Thanks so much,

Rose

20/7/22 declining moon

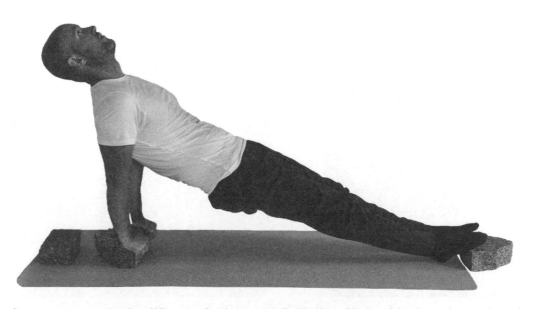

Do a reverse plank with your feet on one Palliative Pilates block and your hands on another. Hold the plank for thirty seconds and then release. Repeat five times.

REPORT
Drawing Sessions
Monika M. Beyer

Palliative drawing sessions
with Olav Westphalen on
Saturday, July 9th, 2022.

I had no idea what to expect—
but I signed up right away.
The exhibition space in the Künstler-
haus Bremen is immediately filled with
participants with an energy of mutual
trust and without judgment—there is
nothing wrong here! It's all about
feeling the charcoal in your hand,
the sheet of paper on the wall and
being present. Sensitively and wit-
hout judgment Olav introduces the
task—vertical strokes, side by side,
a feeling, where does the stroke want
to begin, where does it want to end,
with what intensity does the
charcoal penetrate the surface
of the paper.

PAUSE.

New sheet, new task.
Blind drawing with a blindfold.

Soft delicate sounds are heard.
With my hands I feel the size of the
paper in front of me—an inner voice
tells me: break the charcoal and work
with both hands simultaneously.
I sink into doing, forgetting SPACE
and TIME completely in feeling the
presence of the charcoal in my hands
and the description of the meandering
and directions of a three-dimensional
space that opens up before me. And
I am in the experience of drawing
being a kind of 'two-stream' from brain
and heart directly into the hand—
a kind of spontaneous archaeological
uncovering on a soul level.

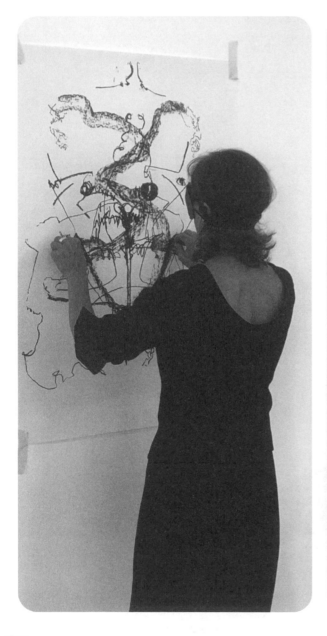

Photos: Künstlerhaus Bremen

Wie stirbt man genau?
Ruth Rubers

Im Rahmen der Ausstellung *The Palliative Turn* im Künstlerhaus Bremen findet ein Friedhofsspaziergang mit Jana Thiel statt, an dem Ruth Rubers mit ihrer fünfjährigen Tochter teilnimmt. Im Anschluss interviewt sie ihre Tochter und einige ihrer Freund:innen zum Thema Sterben.

Kennst du jemanden, der gestorben ist?
* also der Opa von meinem Papa ist mal gestorben und der war richtig alt
* unser Hund ist gestorben und das war der süßeste und ich vermiss ihn sehr
* ich weiß nicht, ich glaub mal eine Frau, die krank war

Wie lange lebst du noch?
* so zwei Monate vielleicht
* 8 und morgzig
* ganz lange, ich will immer ein Kind sein

Wann stirbst du?
* wenn ich eine alte Oma bin und so verschrumpelte Haut habe
* oder wenn ich mal einen Unfall habe und keinen Helm auf und dann kommt ein superschnelles, ganz doofes Auto und fährt mich einfach um
* auf jeden Fall dauert das noch sehr lange

Wie stirbt man genau?
* hm, ich weiß nicht, wenn man einfach so tot ist
* also ja ein alter Mensch stirbt auch manchmal im Krankenhaus
* man legt sich ins Bett, macht die Augen zu und dann wird die Haut einfach schlapp … so ganz flach

Was passiert mit dir, wenn du gestorben bist?
* dann vergraben die mich unter der Erde und ich darf mir einen Stein aussuchen
* dann komme ich auf den Friedhof, Feuer möchte ich nicht, wenn ich schon richtig gestorben bin, nur vielleicht vorher
* ich will auch nicht verbrannt sein, das ist mir zu heiß und dann wird der Mensch so schwarz und stinkig

Du willst verbrannt werden, während du noch lebst?
* ja, wenn ich lieber sterben will, dann kann ich einfach verbrennen
* (Kopfschütteln)
* auf keinen Fall

Kannst du dir vorstellen, sterben zu wollen?
* nein, ich will nicht sterben
* naja, wenn ich irgendwann mal Sterbzeit habe, dann schon vielleicht, die Menschen können ja nicht für immer und ewig leben, das ist dann vorbei
* ja, dann möchte ich lieber sterben, wenn ich überall Schmerzen habe. Opa H. hat das auch schonmal gesagt, dass er bald eine Tod—Tablette nimmt und dann stirbt er, aber ich darf das eigentlich keinem sagen

Denkst du dir das gerade aus?
* ja, eigentlich war das eine Quatschgeschichte nur so aus meinem Kopf, aber ich wollte das mal sagen
* mein Opa P. ist auch gestorben und meine Oma lebt aber noch
* ich hab auch einen Opa, aber der hat noch keine grauen Haare und ich glaub, der will nicht sterben

„Jemand wird von einem Auto mit großem Motor überfahren",
Künstlerin Ruth Rubers' Tochter Raya, 5 Jahre

Wie fühlt sich Sterben an?
* nicht so cool, also es tut gar nicht weh, also es tut weh, aber alte Leute fühlen das nicht mehr so schlimm und dann ist es ja auch egal
* wenn man so rumliegt und sehr alt ist und dann weint man und dann kommt so ein Moment und vielleicht flieg ich dann weg, also ich bin dann weg und dann bin ich einfach tot *blip*
* also ich denke, es wird sehr schmerzhaft und ich will da lieber nicht dran denken

Wo kommst du hin, wenn dein Körper gestorben ist?
* das ist erstmal bestimmt so dunkel oder so
* ich vergammel einfach unter der Erde, aber das macht mir dann nichts
* also vielleicht kann ich dann ein anderes Kind sein, das möchte ich gern, aber eigentlich kann es auch sein, dass ich einfach weg bin

Kommen denn alle Menschen nach dem Tod in einen neuen Körper?
* ja das können alle, nur manche wissen das leider gar nicht, wie das geht, und dann machen die das auch nicht
* nein, aber das wär schön, wenn ich dann wieder ein Baby sein könnte und meine Mama kuschelt immer mit mir und ich hätte sehr viel Spielzeug und ein schönes warmes Leben
* ich kann doch nicht in einen anderen Menschen rein, aber ich verwandel mich dann in einen Roboter *stampf, stampf, schrei* und mache alles platt

Wie kommt man denn in einen neuen Körper oder Roboter?
* das weiß ich auch nicht
* wenn man sich das ganz doll wünscht, dann geht das so *wuuuiiidss* und dann ist man in einem anderen Kind drin
* ich bin das dann einfach

Wenn du jetzt mal die Augen schließt, was bist du dann?
* ich bin immer noch C., nur mit Augen zu
* (Kopfschütteln) ich bin die Füllung
* ich bin eine Kugel, die so im Wasser schwimmt

Wo warst du, bevor du in diesem Körper warst?
* also bevor ich ein Kind war, war ich ein Baby
* ich war ein dicker Bauch
* davor war ich gar nichts, auch keine kleine Blase oder so

Was möchtest du noch tun, bevor du stirbst?
* auf meine liebsten Spielplätze gehen und ganz viel mit meinen Kindern
und Enkeln spielen
* meine Freunde besuchen und ich will mal ein echtes Pferd haben
* ich möchte P. heiraten und wenn wir dann immer so Hand in Hand spazieren
und mal in den Urlaub fahren und schön verliebt sind, dann will ich ein echtes
Krokodil sehen, aber nicht so dicht ran, dass mich das beißt

Wie wird das sein, wenn mal jemand stirbt, den du kennst?
* oh, dann bin ich sehr traurig, auch jetzt schon, wenn ich dran denke
* ich werde die Person jedenfalls sehr vermissen
* wer stirbt denn als Nächstes?

Die Zeichnung ist in einem anderen Zusammenhang entstanden, hat aber auch einen palliativen
Touch, deshalb habe ich sie ausgewählt. Einer unserer Nachbarn hat sich einen Maserati gekauft
und benutzt die Straße unserer ruhigen Wohngegend regelmäßig dazu, das Tempolimit um etwa
200km/h zu überschreiten.

Olav Westphalen, *Mom Tattoo*, 2021. On 30 September 2021, my mother applied a mom
tattoo that she had designed herself onto my left upper arm. It shows a whale holding a banner
with the letters M, O and M. This occurred during a public event at the Brandenburgischer
Kunstverein Potsdam, Germany.

Crowd Mum
Louise Ashcroft

Is it actually true that in British law a pregnant woman is allowed to piss in a policeman's hat? Because today this is my only remaining incentive to get up the duff. Some days my childlessness is involuntary, other days I want no responsibilities at all except writing whimsical prose in an expensive East London coffee shop after an idyllic bike ride through my local nature reserve, which today smells of sun-ripening wild blackberries. Yes, parents, I have the luxury of free time, by myself–the price I pay for genetic obsolescence. I did not choose this though, it chose me–like an accidental pregnancy, my childlessness just sort of happened, and maybe it was a 'mistake' but right now I love and care for it very much. I can have my kid and eat it (as they don't say), by helping my mates out with their kids occasionally in the school holidays.

 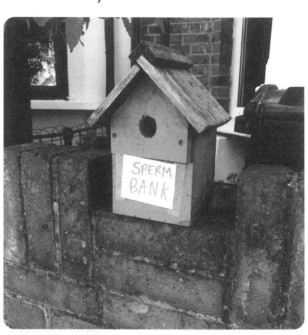

Louise Ashcroft's performance *Bird Hut Sperm Bank* at the Camden People's Theatre in 2022 tells the humorous story of the improvised sperm bank she builds outside her house, reflecting on who gets to have kids, who doesn't, and why we need to rethink the nuclear family. Photo: Louise Ashcroft

Last time I went to a café, the kids I was babysitting haggled ice creams out of me (for breakfast) and we had to take a Feast and Twister into public loos because they suddenly both urgently needed a wee, and had waited for the most perilous moment to test the laws of physics and my multitasking abilities. That day, we had the best time together, making plans for a 5D fantasy marble run, and visiting the 'wacky warehouse' soft-play pit-of-pestilence that was responsible for a 24 hour vomiting bug I woke up with the following day. It seems that the youth and their bacteria have heard I'm performing a serious comedy show about reproductive ambivalence, and they've now got it in for me. I phone a single mum friend to whinge about being ill, and she confirms that small kids are notoriously bio-hazardous. How on earth does a parent cope, if they're ill and they've got two sick kids to look after?

These particular babysittees always insist on asking me for stuff they're not allowed, then shaming me when I buckle, rolling their eyes and saying 'mum would never let us have a slushie', before eventually declining the luminous offering that they'd coerced out of me in the first place. I fear my girlfriend is right when she says that if we had kids I'd never set any boundaries and she'd be left with all the bad-cop stuff. This summer, I'm making my first forays into how I could be a 'crowd mum' instead of having kids of my 'own'; a low-key alternative to running off to join the hippy coparenting communes I'd been browsing online all spring. Maybe I'm kidding myself that this

occasional babysitting constitutes being a 'parent', as ultimately I have the choice about when to clock on or off, like an Uber driver. But like the Uber driver's contractual freedom, most of the reality of having kids is not really a choice, and our societal fixation on choice is tied up with a breed of capitalism which fixes power in the pockets of an elite minority of rich men. Many parents think that because they've 'chosen' to have kids they should have to deal with the difficulties of it themselves (and would feel bad asking me for help), but they did not choose for childcare to be extortionate (or for childcare workers to be undervalued and underpaid!), just as they didn't choose for their employers to be inflexible or for no maternity pay on their precarious creative industry contracts. The ideology of choice lets society off the hook by making individuals wholly responsible; wrongly justifying society's failure to share responsibility to care for each other. On holiday in the town of Martigues (France) this summer, I saw a local newspaper advertising mayor-funded, means-tested summer childcare costing one euro thirty two cents a day (up to ten euros a day for the fat cats). When I returned to this blessed isle, an arts worker I talked to in Newcastle said she spends more than £65 a day to get her baby looked after so she can work; and my London friends would probably pay double that. In reality, not much of having or not having kids is a choice, just as the need for period products was never a choice (despite it having historically been taxed for so long), and so we should not treat caring for human bodies as industrial pursuits – neither linguistically nor economically. The language of choice should be replaced with the language of rights. My emails have pinged daily with dozens of reproductive industry comms, since I got quotes from all the IVF and IUI clinics at a bunch of fertility trade fairs. How has the human species managed to privatise its own reproduction? Future dinosaurs will laugh about this when they claw over petrified cryo-clinics in our sixth mass extinction climate change fossils.

The barriers to having kids, which I stumble through in my daily life, and in my one-woman comedy theatre show *Bird Hut Sperm Bank*, make having kids a nearly impossible choice for me, and maybe I don't want it to be a binary choice anyway – because this summer I am choosing not to choose, I'm going to have my baby and eat it, by helping out mates with their kids. WE don't have to do it alone, and the real choice is the freedom to invent new models of coparenting together. But today, I'm going to sit on my own and read a book called *Survival of the Friendliest*, about the anti-individualist, non-violent, feminist economics of Bonobo monkeys, and how we got Darwin all wrong. But, it's hard to concentrate on reading, because the woman next to me is FaceTiming her one year old nephew in a really loud, annoyingly high-pitched, faux-cute, adult-talking-to-a-baby voice. I would prefer a world where babies talked to adults in fake adult voices, but not everything is a choice.

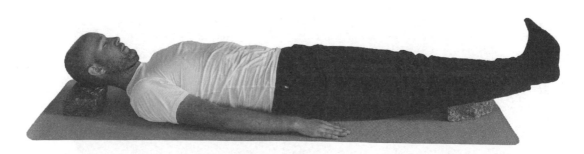

The final resting position. Lie down with one Palliative Pilates block under your head and one under your feet. Close your eyes and relax for five minutes.

REPORT
Cabaret Impedimenta at the Edinburgh Festival Fringe
Harry Haddon

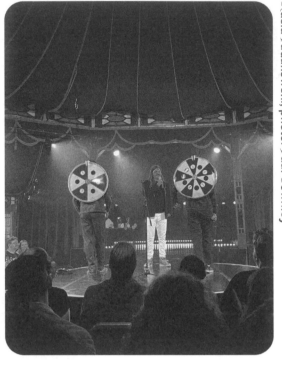

John-Luke Roberts introducing the show, with the 'Impediminions', left Harry Haddon, and right Kasia Fudakowski, photo: Paul Townley

Late-night shows at the Edinburgh Fringe—the world's largest arts festival held every August—are supposed to have a chaotic energy. They're odd places. Decorum is peeled back, exhausted comics do strange things for laughs; private thoughts—and parts—are shared to loose crowds. At this year's fringe AP_T delivered their own late-night show presenting the only cabaret at the fringe aimed at replicating the slow act of dying on stage.

Cabaret Impedimenta is a chaotic variety show pitting six performers against a growing list of impediments.

The show is an evolution of the evening put on at KW's Pogo Bar earlier this year (see page ㉟). It works like this: a wheel is spun to choose an act; another is spun to choose an impediment (performers and audience actions designed to impede the act). With each new act an impediment is added, until the last act is dealing with all of them at once. Or as Kasia Fudakowski, one of the AP_T members putting on the show described it, 'a comically sped up version of life's degenerative process in six acts.'

We put it on twice. First in front of about 50 people, and the second for about 120. The impediments outdid themselves. A Victorian Ghost, played by Madeleine Bye, haunted and spookily harassed performers throughout their acts, stealing their props, and, once, their glasses; the Sports Commentator played by Josh Glanc described the action on stage; the Businessman Making a Phone Call, played by Joz Norris, tried to get his Google Calendar synchronised so he could 'move forward'; professional Hecklers, played by Mark Watson and Eleanor Morton delivered personal and specific heckles at the performers; Liza Minelli, played by Sooz Kempner, was, well, Liza Minelli, who constantly tried to take centre stage; Contemplate Your Own Death was played by Kasia Fudakowski who donned a black shroud, stalked onto stage, and hit a gong stopping the show for a minute so everyone could contemplate their own death; and finally, the audience, throwing plastic balls at the acts.

Both shows failed beautifully and succeeded chaotically; the impediments impeded, and the acts

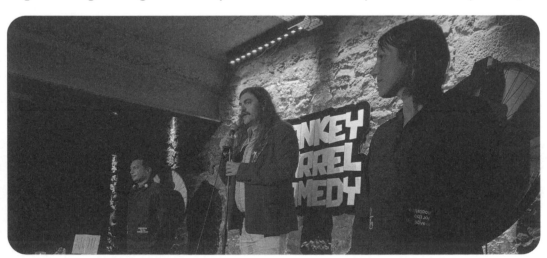

John-Luke Roberts introducing the show, with the 'Impediminions', left Harry Haddon, and right Kasia Fudakowski at Monkey Barrel Comedy, Edinburgh Festival 2022, photo: Bernd Grether.

The performers and impediments receive a standing ovation after the second show.
photo: Paul Gownley

somehow survived to much cheering and support from the crowd who gave a standing ovation at the second show. @the_beckster_ on Twitter wrote, 'Genuinely the funniest show I've been to in a VERY long time! Was it a show? Was it a cheese fever dream?! Who knows?! … LOVED IT!!'

While @CpgemC simply said, 'Pure, magnificent chaos.'

That it didn't completely fall apart was down to the acts soldiering on. In fact, it was when an act overcame the impediments that the response from the audience became more than just laughter. In the second show Grace Petrie, a folk singer who arrived thinking this was just a straight set, had to sing in a trio with Liza Minelli and a Victorian ghost, as a businessman loudly negotiated a deal, hecklers heckled, and the commentator spoke over her, all the while being pelted with balls. Her refusal to give in, just singing louder, strumming harder, meant she triumphed over death (in a theatrical sense) and revealed a surprising beauty behind what could simply be a very silly show.

John-Luke Roberts, long-time alternative comedian, APT member, and host of the shows, said afterward, 'the most exciting thing to see was how the format killed the normal focus of a cabaret or comedy set. All eyes are normally guided to the magician, or the poet, or whoever is performing, and that performer's act is designed to control and direct that gaze.

In Cabaret Impedimenta, though, the audience was confronted with so many things happening, that there was no one thing to concentrate on – and this freedom created a different manner of entertainment.'

Nobody asks a late-night fringe audience to engage with contemporary art, that would be an impediment too far. Especially as contemporary art seems to spurn humour unless it is achingly, self-referential. But Cabaret Impedimenta back-doored a bit of palliative art into an hour of nonsense. While the audience was probably not thinking about the palliative nature of the show, they became part of the art. As Fudakowski put it, 'by introducing, accepting, even relishing each impediment, the audience is asked to watch an act die.' Did they die? They struggled perhaps, but instead of everything falling apart something new emerged. With the performers incorporating the impediments into their acts—seamlessly or awkwardly, it didn't matter, as both were funny— there was none of the oppressive silence that normally accompanies a failing act. And maybe that's the message found in the show, or as Roberts puts it, 'we'd thought the accumulating impediments would signify the march of the body towards death, and maybe they did, but the stage had so much life in it.'

A massive thanks must also go to Lianne Coop and Mark Watson from Impatient Productions without whom we would not have been able to put on this show.

List of Acts

1st Show:
Amber Topaz (Cabaret Artist)
The Lovely Boys (Sketch Group)
Steve Griffin and Nathan Jones (Magicians)
Sami Abu Wardeh (Comedian)
Ada Campe (Cabaret Artist)
Luke Rollason (Comedian)

2nd Show:
Ada Campe (Cabaret Artist)
Diva Yasmine Day (Singer / Comedian)
Grace Petrie (Singer / Songwriter)
Attila the Stockbroker (Punk Poet)
Tom Crosbie (Rubik's Cube Act)
Lachy Werner (Ventriloquist / Comedian)

On Earth We're Briefly Gorgeous

A Novel

Ocean Vuong

APT Reads

ON EARTH WE'RE BRIEFLY GORGEOUS
Ocean Vuong
recommended by by
Xavier Robles de Medina

'It's true that, in Vietnamese, we rarely say I love you, and when we do, it is almost always in English. Care and love, for us, are pronounced clearest through service: plucking white hairs, pressing yourself on your son to absorb a plane's turbulence and, therefore, his fear. Or now—as Lan called to me, "Little Dog, get over here and help me help your mother." And we knelt on each side of you, rolling out the hardened cords in your upper arms, then down to your wrists, your fingers. For a moment almost too brief to matter, this made sense—that three people on the floor, connected to each other by touch, made something like the word family.'

Nearly all of
Octavia E. Butlers' Books
recommended by Dafna Maimon

Last summer a friend lent me Octavia E. Butler's *Wildseed* to take with me on holiday to Athens. A few pages in, I was no longer exploring what was left of ancient Greece; instead its sounds and smells had become a backdrop to the book's enchanting, shape-shifting African protagonist Anyanwu, who spends weeks at a time as a dolphin to take breaks from her toxic but non-disposable lover. Some months later I returned to Butler again and read *Kindred*, and subsequently decided to ingest every book she ever published before I die. Butler's dystopian sci-fi worlds of biological wonder, metamorphosis, and the ever complex power dynamics of symbionts and parasitic relationships spanning race, gender, and family ties—all situated in scenarios of rampant climate change, pandemics, out of control capitalism, and fascist politicians literally trying to 'make America great again', along with countless other

predictions all too ominously echoing our current reality—left me in a state of heightened sensorial awakening of both hope and despair.
Thinking of Butler's writing in relation to the Palliative Turn, the trilogy *Xenogenesis* comes up a lot, with its aliens who have saved or captured (depending on whose perspective one takes) the human race on a distant planet where they are prevented from reproducing amongst themselves. The healer-aliens believe it to be too cruel to allow human reproduction, as the species is both inherently intelligent yet hierarchical, and as such, will always lead itself to extinction. The multi-tentacled aliens instead resort to cross-species breeding, themselves morphing into river-slug-like-creatures that eventually dissolve into the earth if left alone and without sufficient physical touch.
It took four months to complete the mission of absorbing Octavia E. Butler's legacy, leaving only *Survivor*, the author's only disowned pages, unread. Perhaps in remaining so, the out-of-print and hard-to-come-by book may prolong my life span; future goals spawn hope to go on.

GROVE
Esther Kinsky
recommended by Simon Blanck

I started reading this book during my week in Bremen working with the APT show at Künstlerhaus Bremen and photographing Bremen's graveyards. The book had a really palliative pace and was not at all a page-turner, however it was always comforting to return to and receive some snippet about the experience of rural Italy post a major bereavement.
The main reason I want to include it here is what I found on the second-to-last page when I finished the book back in Sweden. The author writes about feet and death in a painting by Fra Angelico. Several times while roaming Bremen's graveyards with

my camera I found myself drawn to the feet of the statues of funerary moments, and also to the feet of the mummified bodies in the Bleikeller under the Bremen Cathedral. The quote from the book goes: 'The feet of the dead are a merciless sight. They say: Death, even before the hands do, and still we want to hold them, warm them, cover them by shrouding and touching find away to undo or at least to hush their deadness. The helplessness of the bereaved before the dead body while fumbling around the feet of the dead is inscribed in this painting.'

communal tasks and large-scale public works, and dissolve them as soon as the task was completed without letting them coagulate into class difference. There are examples of people who knew agriculture, but chose not to practise it, because they preferred an economy of immediate return and so on. That alone makes for an exciting read. And beyond that I find it smart for revolutionary theorists to step away from contemporary skirmishes and instead go after the root assumptions, propping up the seemingly self-evident societal arrangements we live in today.

THE DAWN OF EVERYTHING – A NEW HISTORY OF HUMANITY
David Graeber and David Wengrow
recommended by Olav Westphalen

It is commonplace to say that history is written by the winners. We have become quite good at taking apart such narratives, except, strangely, when it comes to the first 95% of human history. Everybody seems to agree about what pre-history was like and what it tells us about our species: we can keep the peace in clan-sized bands, but beyond that, when left without strict oversight, we inevitably go *Mad Max*. Graeber and Wengrow respond to this: '... such pronouncements are not actually based on any kind of scientific evidence. (...) there is simply no reason to believe that small-scale groups are especially likely to be egalitarian—or, conversely, that large ones must necessarily have kings, presidents or even bureaucrats. Statements like these are just so many prejudices dressed up as facts, or even as laws of history.' *The Dawn of Everything* is a 600-page brick by David Graeber, the late social theorist who was instrumental in fomenting Occupy Wall Street, and the archaeologist David Wengrow. The book is beautifully written, and seems to be rigorously researched. I have read some online push-back against the book, but nobody seems to contest the many, detailed archaeological narratives that introduce us to a plethora of societal structures that have existed and flourished, and which deviated profoundly from the standard narrative. I didn't know that there were hunter-gatherer societies 10,000 to 30,000 years ago that could establish temporary hierarchies, for

THE MONARCHY OF FEAR
Martha Nussbaum
recommended by Olav Westphalen

The Monarchy of Fear represents a philosopher's attempt to grapple with societal developments that are no longer rationally understandable, even if we spend a lot of time trying to rationalise them. Nussbaum delineates the emotional forces underlying our everyday rhetoric. Fear, the earliest and most basic human emotion, takes a central role. While Nussbaum's sympathies lean towards progressive liberalism, she finds the same veiled emotional forces at work on the right and left of the political spectrum. She draws on modern and ancient sources. Lucretius looms as large as child psychologist D. W. Winnicott. Sometimes, the book reads a bit harmless, to me at least, but its core argument—that it makes no sense to quarrel about specifics if we don't also acknowledge the massive emotional torrents fuelling each and every position—is convincing and could be very useful. The book, it seems, wants to reach mainstream audiences (hence perhaps the occasional harmlessness) and ask them to do something radical: to reconsider their core political beliefs and acknowledge the degree to which they are a rationalised cover for forces that are not just irrational and largely out of our control, but also often beyond our conscious awareness. This book ultimately argues for a society that actively counters the corrosive effects of fear, disgust and contempt by creating social structures that foster compassion, trust and love.

THE UNINHABITABLE EARTH – LIFE AFTER WARMING
David Wallace-Wells
recommended by Olav Westphalen

I'll introduce this book with a promo-blurb by Andrew Solomon, a writer I admire: 'The Uninhabitable Earth hits you like a comet, with an overflow of insanely lyrical prose about our pending Armageddon.' Wallace-Wells describes what humans will face in the rather near future if we proceed to go about our business 'as usual'. And, for the moment, there are no indications that we won't. All the Teslas and Gretas aside, the graph describing the carbon dioxide concentration in the atmosphere has been going up without a dent ever since 1958, when daily measurements commenced at Mauna Loa Observatory. The Uninhabitable Earth is not an easy read for anyone who likes humans. It is fire-and-brimstone fearmongering. It has been criticised for being somewhat exaggerated, based on the IPCC predictions for global warming. I have two things to say to that: a) If I scream at the top of my lungs that there are a thousand gigantic, flesh-eating spiders amassing around the house, you don't answer 'Well, that looks more like 975 spiders to me, give or take a few.' b) The much-quoted UN reports on climate change don't consider the feedback effects that have been set in motion by human-caused warming, such as the diminishing albedo effect (loss of reflective snow cover) and methane emissions from thawing permafrost which, alone, will cause global temperatures to rise for millennia to come. Why is this horrible book palliative? Because it provides a grim but honest diagnosis. And it thereby takes denial and all kinds of fake solutions and quack schemes and climate hypocrisies, such as silly talk of circular economies, green capitalism and carbon-sucking fans in Switzerland, out of the picture. Once the direness and scale of the problem have been accepted, there are things to focus on, to mitigate suffering, to buy us time, and to make the time we still have count. If that's not palliative, what is?

SHIFTING THE SILENCE
Etel Adnan
recommended by Maxwell Stephens

'I would have been an archeologist, and would have found a necklace in pure gold, and wondered to whom it had belonged. Not necessarily a woman. I'm a passenger on planet Earth, itself a passerby. The empire crushed as if it were made of cardboard, and we retrieved some memories which will die with us, or survive, for a while … But everything lasts just for a while, probably eternity itself.' (bottom, p. 37)

DIE STRASSE
Cormac McCarthy
recommended by Ruth Rubers

Zuerst ein Zitat vom Anfang, als die großartige Hoffnungslosigkeit gerade erst beginnt aus den Zeilen zu tropfen:
„Geht's dir gut?, fragte er. Der Junge nickte. Dann marschierten sie im stahlgrauen Licht die Asphaltstraße entlang, schlurften durch die Asche, jeder die ganze Welt des anderen."
Dieses Buch habe ich kürzlich gelesen und war ganz verzückt, wie der Autor Postapokalypse mit Weihnachtsgeschichte vermischt. Es geht nicht vorrangig um den Tod einzelner Personen, vielmehr ist die ganze Welt gestorben… also fast.

Ways to Foster a Healthy Relationship with Death:
A Non-Hierarchical List (Ongoing)

by John-Luke Roberts

1. Breed worms. Leave instructions in your will for these worms to be buried with you once you die. In the meantime, give the worms names, talk to the worms, confide in the worms. In other words: befriend the worms that will eat your carcass.

2. Before flushing, hold a funeral for each bowel movement. Wear black, light candles, make a speech, invite guests.

3. Carry a portable speaker playing the 'beep beep' of a hospital heart monitor at all times.

4. Sit on your hand until it goes numb. Contemplate that hand.

5. Buy a number of pets with different life expectancies (e.g. from stick- insect, through cat, through parrot, to turtle). This will help you maintain regular contact with loss throughout your life.

6. Have a tombstone carved with your name and date of birth. Carry it with you everywhere.

7. Keep a skull handy in your living room to look at. Get a smaller skull for when you're travelling.

8. Keep your food waste and let it rot.

9. Close your eyes more often. Close your ears as well.

10. Eat a spoonful of soil once a week.

11. Sit in a wooden chair and look at a tree. Then, sit in the tree and look at the wooden chair. Repeat, until you reach some level of understanding.

12. Date a mortician, or undertaker, or coroner. Look deep into their eyes at any opportunity.

13. Find an electrical box with a "danger of death" sign on it. Practice empathising with the little picture of a person next to a little picture of a bolt of electricity.

14. For the next thirty minutes think "If I were dead, I wouldn't be able to think that," after every thought you think.

15. Imagine you are a person named Beth. Build a backstory for Beth, and live as Beth for increasing periods of time each week. Eat as Beth. Walk as Beth. Dream as Beth. Once you fully know what Beth is like, from the inside out, change the first letter to a 'D.'*

*(If you are already a person named Beth you can skip the first steps).

16. Put on a black and yellow striped sweater and look at a dead bee.

17. Feel your teeth with your tongue. Extrapolate.

18. Communicate with people by pointing at the letters on a ouija board.

Black Circle Astrology
Maxwell Stephens

As we settle into the longer nights, perhaps longing for candles, a good book, a bottle of red wine and a proper quiet time to contemplate the end of all things, our fragile planet rockets through the universe at 107,226 km/h. Even at this pace, the Sun will take a month to waltz through the rest of Libra and into Scorpio. It's a social time that will lean into asking the deeper questions about life and death—this doesn't have to be a solemn proceeding. For water signs, things are charged up for a deep plunge into the subconscious. For air signs, passions and grand visions align. The ongoing shifts in home life will continue even if it hurts and leaves you speechless at times. You are building a new foundation that must somehow be flexible. Let it all come undone if it has to, other voices will have a turn to be heard that can help.

Aries:
Ok, there have been tears, shake-ups, it's on. Be the underdog if you have to. Time to get your butt out the door, the pandemic has worn out your patience. Your feet are on the ground again and if the rules of the game seem a hindrance, the big picture is at your fingertips. For those of you in the first degrees, you may feel a little vertigo—promises may be deceiving. Curse the world if you have to, burn sage or do your taxes even if it all seems fleeting. It is. If you get exasperated and just wanna say, 'Fuck it, let the whole thing burn!', find a friend who will rant with you.

Taurus:
Maybe your sense of home has become unrecognisable, and not necessarily in a bad way. It's certainly no longer a coffin (even if, secretly, the outset of the pandemic was one of your favorite excuses to bundle up on the couch and eat your fave snacks). With a little courage, you can let in those irrational thoughts, or even let yourself bitch about the sausage party that is bringing the world to its knees—yes, the fucking patriarchy! The time is ripe to share your discomforts with others who will help you face the darker side—Give that ol' track a spin for inspiration: 'It's the end of the world as we know it … and I feel fine!'

Gemini:
If you're already an extrovert, look out! Mars has entered your sign and you may run off at the mouth more than usual. You're inspired by grand visions that people need to hear! If you mount a serious critique of the powers that be, your clear message will find a sympathetic ear. Make doubly sure you have your facts straight. You are ready to work through pain so long as you don't ignore the promise of a good long cry or a dip into the dissolution of all that you know and believe.

Cancer:
There is a deep and palpable anger for many of you that is struggling to find a mode of expression. Neptune has been bolstering trust in your intuition for some time now, even if you have the impression of being stuck in quicksand. Help is on the way—at some point in the season you will find yourself unusually eloquent in the art of romance. Go with it, the sadness that seems to sap your strength is a homeopathic one that will teach you empathy for others. Watch the waves tumble rocks until they are smooth, or a waterfall bore away the bedrock below. It can rejuvenate you enough to take on the status quo once again.

Leo:
While you may feel free of immediate concerns, there may be a bit of numbness or a feeling of being on the sidelines of life's great affairs. It's ok to be vulnerable—your friendship circle is nattering away about things you need to hear. You will have to step out of your comfort zone and help is coming if you allow yourself to get dirty in a serious way, and by this I simply mean, get personal. If sadness or fear binds your feet, listening to it will allow you to accept the advice of your posse better.

♍ Virgo:
It's a dark time, dear Virgo, and I know you've made every effort to put things in order throughout the pandemic. If only people would bloody listen to the facts, we wouldn't be on the verge of extinction! This season you may find yourself a bit tongue-tied at times, moving from professing love to wildly raging about

the importance of the urges and emotions, but you'll have to bumble through it and hope that things will work out in the end (your uneasy mantra). You will learn the most from your friends and loved ones, they need your powers of discernment in these troubling times.

Libra:

Two of your favorite influences, Mercury and Venus, are dancing through your sign, bringing you hope, optimism and love this season. You may feel immortal! The energy will be palpable, your gift of the gab will allow you to entice or seduce others with your clearsightedness. Be wary of any groundlessness you might be feeling and make sure to notice the reactions of your audience—you may find it difficult to truly see their needs. Are you focusing on others to avoid your own mortal wounds?

Scorpio:

The Sun will wade into your sign this season, bringing you confidence to speak your mind more freely than usual. Your words will be dark and passionate, you have full recourse to your intuition. While you may possess a fascination with death, power or sexuality that would cause most people to blush or scurry out of the room yelling their safe word—you will find yourself unusually good at connecting with your prey. The real concern, however, is that of the future: what will you do if the music stops and you cannot find a chair to sit in? Developing a plan could be empowering for you at this time.

Sagittarius:

This autumn has more than a few pleasant surprises for you! In the midst of generally dark times, you can be the cosmic cheerleader for a spell. You will have an audience to share your elaborate ideas, and you will feel your love for these things returned to you. For most of you, energy will be boundless, you will start many projects and plans and your expectations can even be unusually realistic. Some of these may slip away, if they get stuck or fall to the wayside, not to worry, what is important can be taken up again.
Remember that you are a mere mortal and to speak from your humble experience.

Capricorn:

Like your fellow earth sign, Virgo, you are having a 'told you so' moment, and it may seem like the only positive feedback you're getting is in the success of your home renovation projects. Some of you born in later degrees of the sign may be experiencing a greater confidence in decisions that you make rather quickly. It's called intuition (are you squirming?) and Neptune has been amping up the game lately. Let's say death is the liquidation of all your assets: what remains of value? While you may take your ego for granted, your friendships this season will be shockingly legible and passionate. Don't let the opportunity to indulge a little slip away.

Aquarius:

If ever there was a time to fuck your way out of systemic problems—in your humble opinion—we may indeed be coming to it! Saturn is bringing concrete clarity to your revolutionary visions for us mortals: Mars (in Gemini) and Mercury and Venus (in Libra) are setting the air signs ablaze this autumn, bringing you courage, clarity and love in you social life. You may experience the odd lump in your throat from a wave of sadness or a bit of a shock that you ignored your basic bodily needs. Your intuition may be quietly warning you not to wander off into the stars.
Keep it as realistic as you can, there's nothing more embarrassing than being tripped up by the simple facts of living: food, shelter, and safety in numbers.

Pisces:

You have been in your element and will continue to be for some time, as Neptune has been slowly making its way through your sign. This autumn will generally be a quiet one, though it may begin with some difficulties articulating what really matters to you. Take the necessary time to work through a few issues with your home and social life. There may be a few false starts that need to be readdressed, or a pronounced, lingering sadness at the pains of the world that are nothing new for you. Toward the end of the season, your existential struggles will be rewarded with flirtatious energy and a renewed ability to say what you want.

APT Timeline

2020

9–12 September
Rattelschneck (Marcus Weimer and Olav Westphalen) are invited as guest cartoonists and asked to develop a 'humour concept' for the 13th Convention of the German Association for Palliative Medicine (DGP), Wiesbaden, DE

17–20 September
AFASIOTOPIA the First Symposium of *The Palliative Turn* with Simon Blanck, Kasia Fudakowski, Annemarie Goldschmidt, Lars Erik Hjertström Lappalainen, Keith Larson, Dafna Maimon, John-Luke Roberts, Lydia Roeder, Olav Westphalen, Salon am Moritzplatz, Berlin, DE

2021

19 August –7 November
Die Palliative Wende – wie würden Sie gern Abschied nehmen? Exhibition Brandenburgischer Kunstverein, Potsdam, DE

19 August
A Call for the Palliative Turn Performance by Nala Tessloff Brandenburgischer Kunstverein, Potsdam, DE

21 August
Duet with a Dying Plant Performance by Per Hüttner and a Dying Plant Brandenburgischer Kunstverein, Potsdam, DE

19 September
Moro, Lasso, Concert / Performance by Nala Tessloff and UnSpoken Consort; Brandenburgischer Kunstverein, Potsdam, DE

30 September
Mom Tattoo, Performance by Olav Westphalen and his mother Berbe Westphalen with Jana Thiel; Brandenburgischer; Kunstverein, Potsdam, DE

1 October
The Behavioural Barometer, Workshop by Annemarie Goldschmidt Brandenburgischer Kunstverein, Potsdam, DE

2 October
Pictures from another world—The St. Joseph's Hospice in India, Lecture by Lydia Roeder

2 October
Public conversation between Keith Larson (Evolutionary ecologist and the Director of the Arctic Centre at Umeå University, Sweden), Bernd Oliver Maier (Vice President, German Association for Palliative Medicine), Olav Westphalen and Gerrit Gohlke (Director, Brandenburgischer Kunstverein); Brandenburgischer Kunstverein, Potsdam, DE

3 October
Kill your Darlings Workshop with Dafna Maimon and Michael Norton; Brandenburgischer Kunstverein, Potsdam, DE

4–30 October
APT KL9 in Stockholm, SE

22 October
The Night Porter, A 6-hour performance by Carima Neusser; KL9 in Stockholm, SE

31 October
The Palliative Turn A public conversation with Kasia Fudakowski, Dafna Maimon and Olav Westphalen

Sorrows, A guided car performance by Carola Uehlken; Brandenburgischer Kunstverein, Potsdam, DE

2022

10 March
An Evening on the Palliative Turn, Pogo Bar, KW Berlin

May to September
Display of APT manifesto poster, catalogue contribution, beach towels with APT manifesto sold at gift shop *In Situ Paradise,* 1st Biennial of Lindau, DE

20 May–30 September
Participation of APT at 25th Gabrovo Biennial of Humor & Satire in Art, BG

7 July
Palliative KüKü (Künstler: innen-Küche—Artist Kitchen) cooked by Harry Haddon; Künstlerhaus Bremen, DE

8 July– 3 October
The Palliative Turn; Exhibition at Künstlerhaus Bremen, DE

8 July
APT Manifesto A performance by Maxwell Stephens, Künstlerhaus Bremen, DE

9 July
Palliative Drawing Sessions with Olav Westphalen; Künstlerhaus Bremen, DE

Exhibition tour with members of APT Künstlerhaus Bremen, DE

10 July
Walk at Riensberg cemetery with Jana Thiel ; Bremen, DE

10 and 17 August
Cabaret Impedimenta at the Edinburgh Festival Fringe

30 September
Duet with a Dying Plant Performance by Per Hüttner: *Film screening* with contributions by Christoph Draeger, Kasia Fudakowski, Nina Katchadourian, Olav Westphalen, Gernot Wieland Künstlerhaus Bremen, DE

1 October
Last Aid in Life Course with Lydia Roeder

The Art of Turning Palliation Into Our Lives at Any and All Parts of Our Life Cycle Workshop with Annemarie Goldschmidt and Per Hüttner

NO KIDS Workshop with Louise Ashcroft

Exhibition tour with members of APT

Open roundtable with members of APT

Palliative Dinner cooked and conceived by Harry Haddon Künstlerhaus Bremen, DE

COLOPHON

Diese Publikation erscheint anlässlich der Ausstellung und des Veranstaltungsprogramms / This publication is published on the occasion of the exhibition and programme of events *The Palliative Turn* im / at Künstlerhaus Bremen, 09.07.–03.10.2022 mit Beiträgen von / with contributions by Carla Åhländer, Louise Ashcroft, Simon Blanck, Christoph Draeger, Kasia Fudakowski, Annemarie Goldschmidt, Teal Griffin, Harry Haddon, Ethan Hayes-Chute, Lars-Erik Hjertström-Lappalainen, Per Hüttner, Nina Katchadourian, Alex Kwartler, Karin Kytökangas, Mathias Lempart, Dafna Maimon, Marit Neeb, Laura Pientka, Sascia Reibel, Xavier Robles de Medina, Lydia Röder, Ruth Rubers, Maxwell Stephens, Jana Thiel & Volker Grahmann, Olav Westphalen und / and Gernot Wieland.

Künstlerhaus Bremen e.V.
Am Deich 68 / 69
D–28199 Bremen
☎ +49 0421 5088 598
www.kuenstlerhausbremen.de
galerie@kuenstlerhausbremen.de

KÜNSTLERHAUS BREMEN

Die Ausstellung und die Publikation wurden gefördert durch / The exhibition and publication were supported by:

STIFTUNGKUNSTFONDS

NEU START KULTUR

KARIN UND UWE HOLLWEG STIFTUNG

Freundes- und Förderkreis der HfK Bremen

Konstnärsnämnden
The Swedish Arts Grants Committee

swiss arts council
prohelvetia

Künstlerhaus Bremen wird gefördert durch / is supported by

Der Senator für Kultur

Freie Hansestadt Bremen

Dank an / Thanks to:
Lars Arrhenius,
Gerrit Gohlke und / and Brandenburgischer Kunstverein Potsdam,
Pia Kristofferson,
Oliver Maier,
Julia Rothe,
Anna, Stella & Noa Westphalen,
Rica Linders,
Frederik Preuschoft,
Janine Behrens,
Leonie Funke,
Barbara Rosengarth,
Rose Sanyang-Hill,
Frank „Trio" Stemmann, den Vorstand des / the board of Künstlerhaus Bremen,
Maxwell Stephens & Mika sowie allen Förderer:innen, die die Ausstellung, die Veranstaltungen und die Publikation ermöglicht haben / as well as all funders for making the exhibition, events and publication possible.

Contributors

Louise Ashcroft
Artist, b. 1983 in Bradford, West Yorkshire, UK, lives and works in London.

Monika B. Beyer
Visual artist, filmmaker, and reincarnation therapist, based in Bremen.

Simon Blanck
Artist, b. 1986 in Trollhättan, Sweden, lives and works in Stockholm.

Kasia Fudakowski
Artist, b. 1985 in London, UK, lives and works in Berlin.

Annemarie Goldschmidt
Specialised kinesiologist, b. 1935, lives and works in Denmark.

Teal Griffin
Artist, b. 1988 in London, UK, lives and works in London.

Harry Haddon
Author, editor, b. 1984 in Durban, South Africa, lives and works in Amsterdam.

Ethan Hayes-Chute
Artist, b. 1982 in Freeport, Maine, USA, lives and works in Berlin.

Niki Katsara
Is a medical student living in Berlin.

Lars-Erik Hjertström Lappalainen
Philosopher and art critic, lives and works in Skarpnäck, Sweden.

Keith Larson
Evolutionary ecologist and the Director of the Arctic Centre at Umeå University in Sweden.

Karin Kytökangas
Artist, b. 1991 in Vetlanda, Sweden, lives and works in The Hague, Netherlands.

Mathias Lempart
Artist and graphic designer, b. 1990 in Poland, lives and works in Berlin.